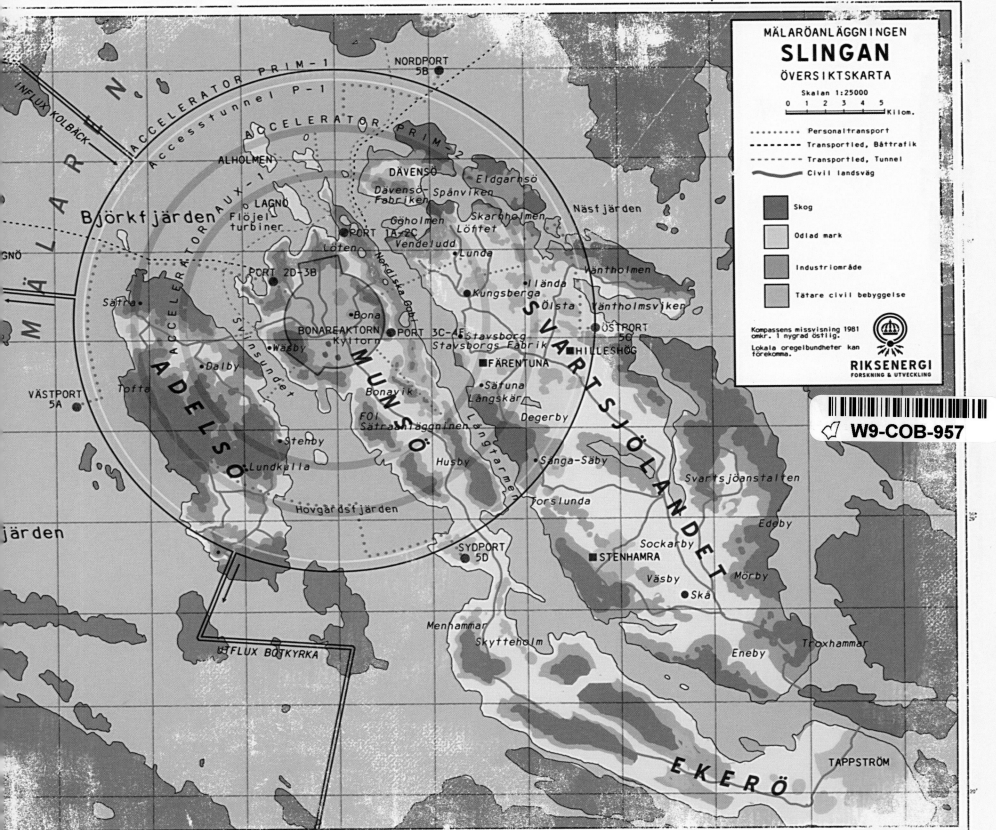

MÄLARÖANLÄGGNINGEN
SLINGAN
ÖVERSIKTSKARTA

Skalan 1:25000

0 1 2 3 4 5 Kilom.

········· Personaltransport
─ ─ ─ ─ Transportled, Båttrafik
─·─·─·─ Transportled, Tunnel
〜〜 Civil landsväg

Skog
Odlad mark
Industriområde
Tätare civil bebyggelse

Kompassens missvisning 1981
omkr. 1 nygrad östlig.
Lokala oregelbundheter kan
förekomma.

RIKSENERGI
FORSKNING & UTVECKLING

W9-COB-957

Ej godkänd ur sekretessynpunkt för spridning.
Statens lantmäteriverk 1981-04-27

130930

TALES FROM THE LOOP

Simon Stålenhag

Skybound Books / Gallery Books

New York • London • Toronto • Sydney • New Delhi

A boy sprints with an invisible line slanting up in the sky
where his wild dream of the future flies like a kite bigger than the suburb.

Tomas Tranströmer, OPEN AND CLOSED SPACES

The Loop was deep underground. It was an enormous circular particle accelerator and research facility for experimental physics that stretched around northern Mälaröarna, from Hilleshög in the east almost all the way to Härjarö to the north; it continued west across Björkfjärden and around the west side of Adelsö, to pass underneath Björkö and its remains of civilizations past. The Loop's presence was felt everywhere on Mälaröarna. Our parents worked there. Riksenergi's service vehicles patrolled the roads and the skies. Strange machines roamed in the woods, the glades, and the meadows. Whatever forces reigned deep below sent vibrations up through the bedrock, the flint lime bricks, and the Eternit facades, and into our living rooms.

The landscape was full of machines and scrap metal connected to the facility in one way or the other. Always present on the horizon were the colossal cooling towers of the Bona reactor, with their green obstacle lights. If you put your ear to the ground, you could hear the heartbeat of the Loop: the purring of the Gravitron, the central piece of engineering magic that was the focus of the Loop's experiments. The facility was the largest of its kind in the world, and it was said that its forces could curve space-time itself.

A BRIEF HISTORY OF THE LOOP PROJECT

The revolutionary powers inherent to nuclear technology became apparent at the end of World War II. It was obvious that comprehensive research within the field of fundamental physics would lead to breakthroughs of great military and civilian importance. In the Soviet Union, the seemingly random discovery of the magnetrine effect had given birth to the wondrous magnet ships, and it had completely revolutionized the transport industry. These events seemed to indicate that broad research would pay off; a wide array of experimental research programs were initiated in Sweden, including in the field of fusion. It was in those pioneering days in the early '50s that the plans for a government owned and operated particle accelerator were hatched. Soon it became clear that it would become the biggest accelerator in the world, more powerful even than the one that had been completed in Nevada a few years earlier.

The project was named The Facility for Research in High-Energy Physics, but was often called the Mälarö facility or, more commonly, the Loop. Con-

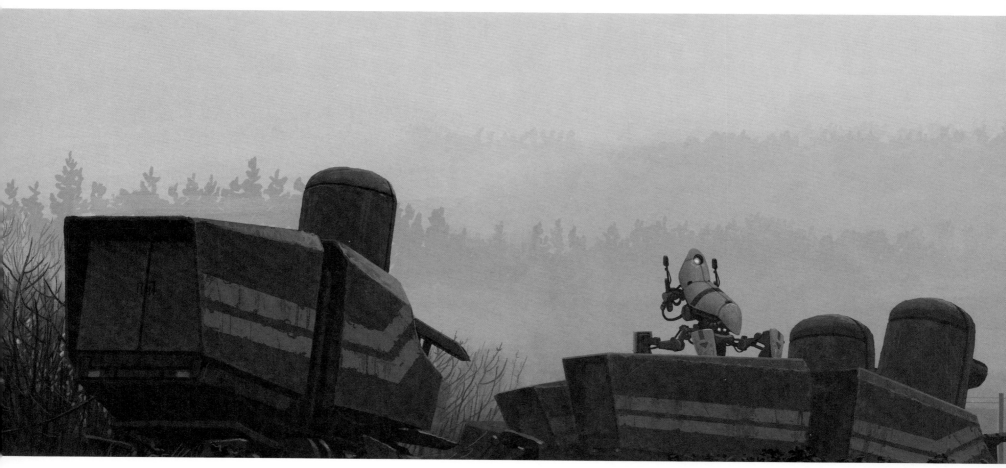

struction began in 1961 and took eight years. It was operated by the newly formed Riksenergiverket (National Energy Agency) and consisted of around twenty research teams with a total of 129 scientists and science students. Including service personnel, the facility eventually had several thousand employees. The Loop was inaugurated in 1969, and the first experiment was conducted in July 1970. The capacity of the facility was increased over the years, and the Loop remained the world's most powerful accelerator until its decommissioning in 1994.

The illustrations in this book focus on my generation of Mälarö children and the environment we grew up in. As to the facility itself, its machines and other technology, I have tried to illustrate it all in detail. I have based my illustrations and descriptions on a massive amount of my own field notes and photos, but also on documentation from vendors and subcontractors. I have also gone through a lot of reports and documents pertaining to the

Loop project that have been made available by Riksenergi. The goal of my work has in no way been to depict the rise and fall of the Loop project objectively or exactly; rather to give a personal, subjective, and sometimes simply entertaining look into how the project, and Riksenergi, affected the people and the landscape, and how it was to grow up in that environment. Sometimes I even leave Mälaröarna to describe other places and memories that I have considered to be pertinent to the mood and tone of the book.

The stories I tell here are mostly based on the memories of myself and others: especially my childhood friend, Ola, who possesses a near-eidetic memory and has been able to recall all our schoolyard stories down to the smallest detail. I am eternally grateful to him for his help with the content of this book.

Simon Stålenhag, Kungsberga, spring 2014

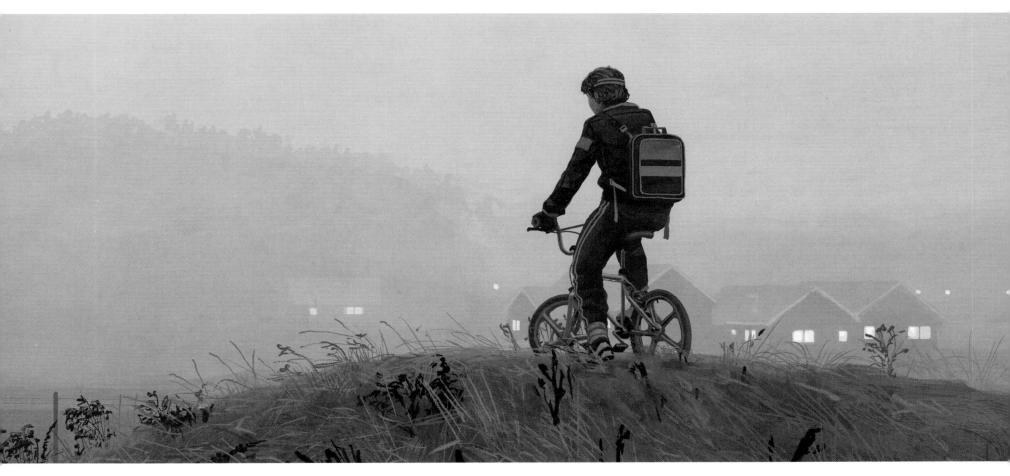

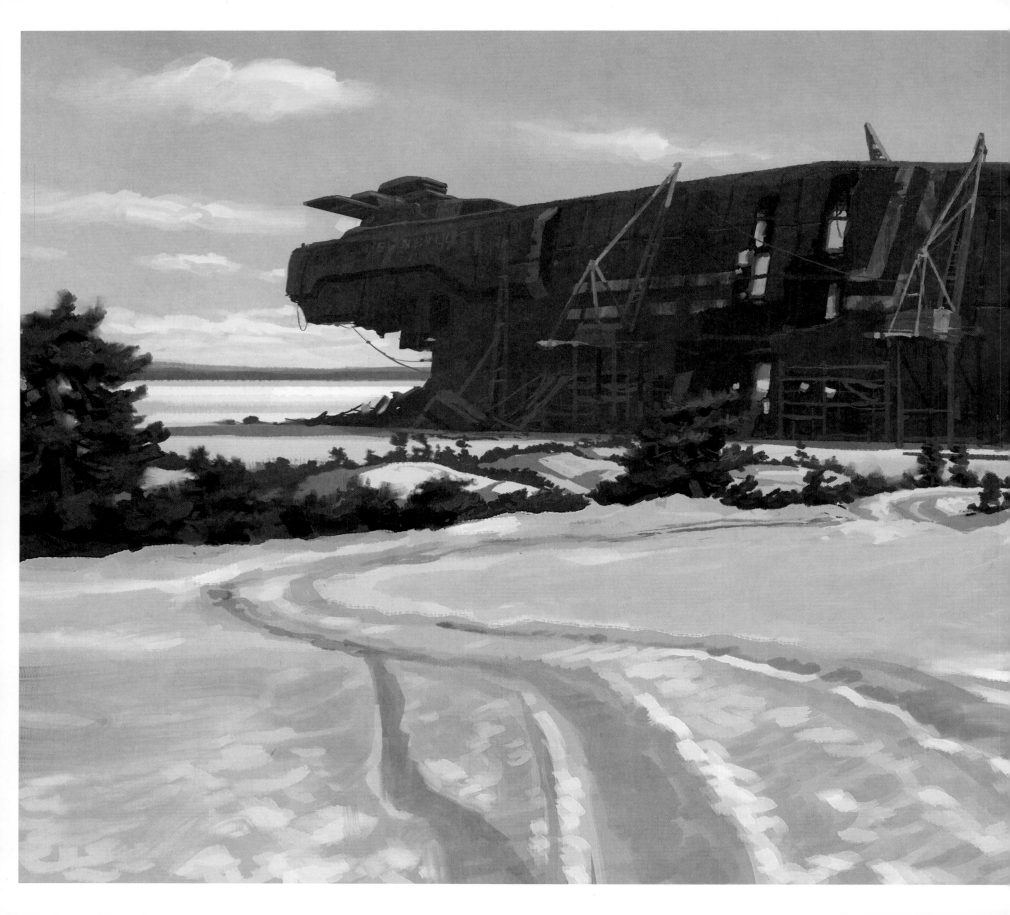

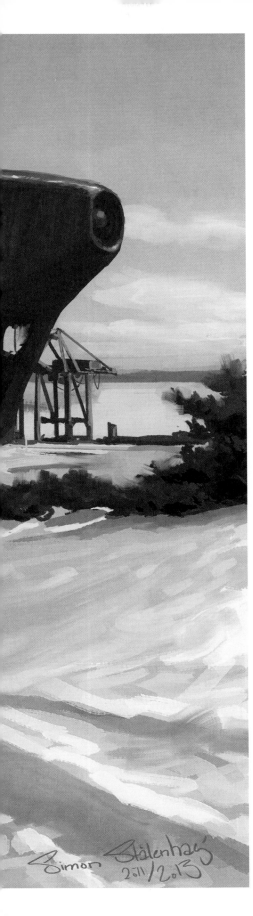

THE HULK AT BASTLAGNÖ

The magnificent hulk of MS Ancylus could be seen from Svartsjölandet if you went out on Göholmen's northwestern point. She rose above the horizon, far away and on the other side of Björkfjärden. From a distance, and through the blue haze over the water, she looked like a South American plateau—a horizontal rectangle above the treetops of the islands. The hulk was a constant part of our plans for expeditions as soon as the ice formed in the winters, but I can't remember us ever daring to go there.

MS Ancylus was constructed at the Wiman shipyards in Sundsvall in the early '60s, and was one of the first magnetrine ships with a single turbine. She was constructed with the express purpose of ferrying ore along the tundra route, but was bought by Riksenergi when the Loop project commenced. Between 1962 and 1968, she conveyed huge amounts of rock and soil out to Prästfjärden where the artificial group of islands called Mälarkransen were built. After she broke down outside Alholmen in 1969, MS Ancylus was taken out of commission and towed to the Bastlagnö shipyards. A protracted judicial process delayed her retrofitting and, when the Wiman shipyards went bankrupt in the wake of the Ural Crisis in 1978, the matter was in limbo until Riksenergi, after pressure from the locals and Naturvårdsverket, finally came in and demolished the hulk in the spring of 1995.

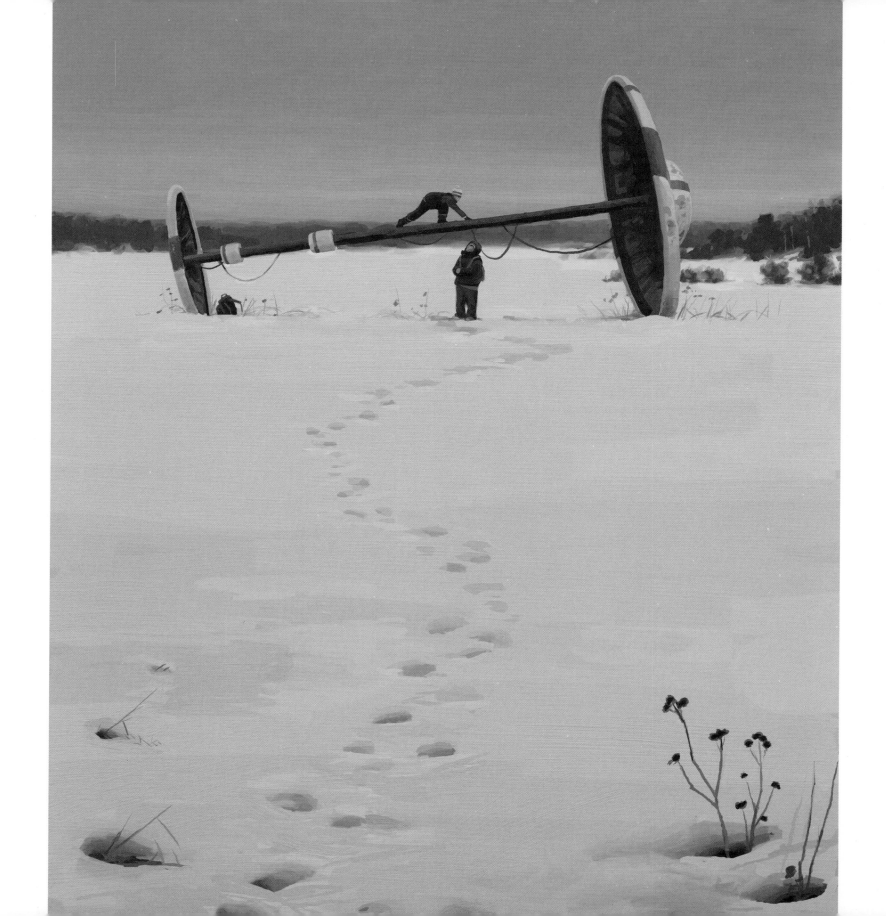

THE AXLE AT STAVSBORG

One day Olof got a black eye during recess. He wanted to run away from school and I went with him. We ran across the fields and hid in the groves to avoid being seen by the teachers.

Olof was always on an adventure and never seemed to want to stop playing. Darkness was falling when we arrived at Stavsborg. A weird piece of junk jutted from the earth in the field, and we ran to it. Of course, Olof wanted to start climbing it, but I felt frozen and tired. I stood and watched while Olof held the fort against a horde of attacking teacher-cyborgs. After a while we got into an argument: I wanted to go to Olof's house and watch a movie, but Olof refused. He even wanted to build an igloo and spend the night in the field. Somehow our argument became an actual fistfight; I can't recall why now, but I remember us rolling around in the snow, pulling hair, and hitting and pinching each other. Later we sat, exhausted and bruised, in the snow. I helped Olof get something out of his eye, and then he told me his father was depressed. Finally, we went to my house and played *Sonic the Hedgehog* instead, and this time I taught Olof the cheat codes.

THE BONA PLANT AND OSSIAN

The three cooling towers at Bona were a constant presence in the landscape on Mälaröarna. They rose from the fields far out on northern Munsö, in the small community of Bona. The main function of the towers was to release heat from the Gravitron, the core of the Loop that provided the facility with the enormous amounts of energy it required. The middle tower was an impressive 253 meters in height, and the towers were a characteristic landmark visible from all of Mälardalen.

The signal sounded at six o'clock every day. It started like a deep vibration in the ground that slowly rose to three horn-like blasts, followed by a drawn-out echo that reverberated across the landscape. The sound was the result of the daily reset of the towers' fifteen huge demister valves. The Signal had eventually become a practical part of Bona families' everyday routines, not far removed from that of church bells of old; you knew it was time to head home to the dinner table when the Signal sounded.

I heard the Signal up close in August 1991. It was one of those one-time things. The Bona boy Ossian had lured me from the youth center with the promise of playing with his Incredible Crash Dummies, but it ended in tears.

Our newly found friendship quickly deteriorated once we arrived at Ossian's house. Ossian assigned all the best toys to himself, and I was soon ostracized when his brother, Oliver, came home. Their mother was downstairs in the kitchen preparing our meal when the Signal sounded. The floor vibrated and I was scared. Ossian and Oliver, heroes of the moment, told me that the Signal was a warning heralding an imminent meltdown in the Gravitron and pushed me into a closet, telling me I had better stay there if the Earth itself was sucked into a black hole. Then they rushed down into the kitchen and gorged themselves on all the blood pudding.

I felt a shameful relief when my father appeared to take me home. During the ride back to Svartsjölandet, my father assured me the Earth would not be sucked into a black hole at all. Despite that, I became more and more anxious, and for weeks I walked around holding my breath, awaiting the end of the world—especially at dinner time.

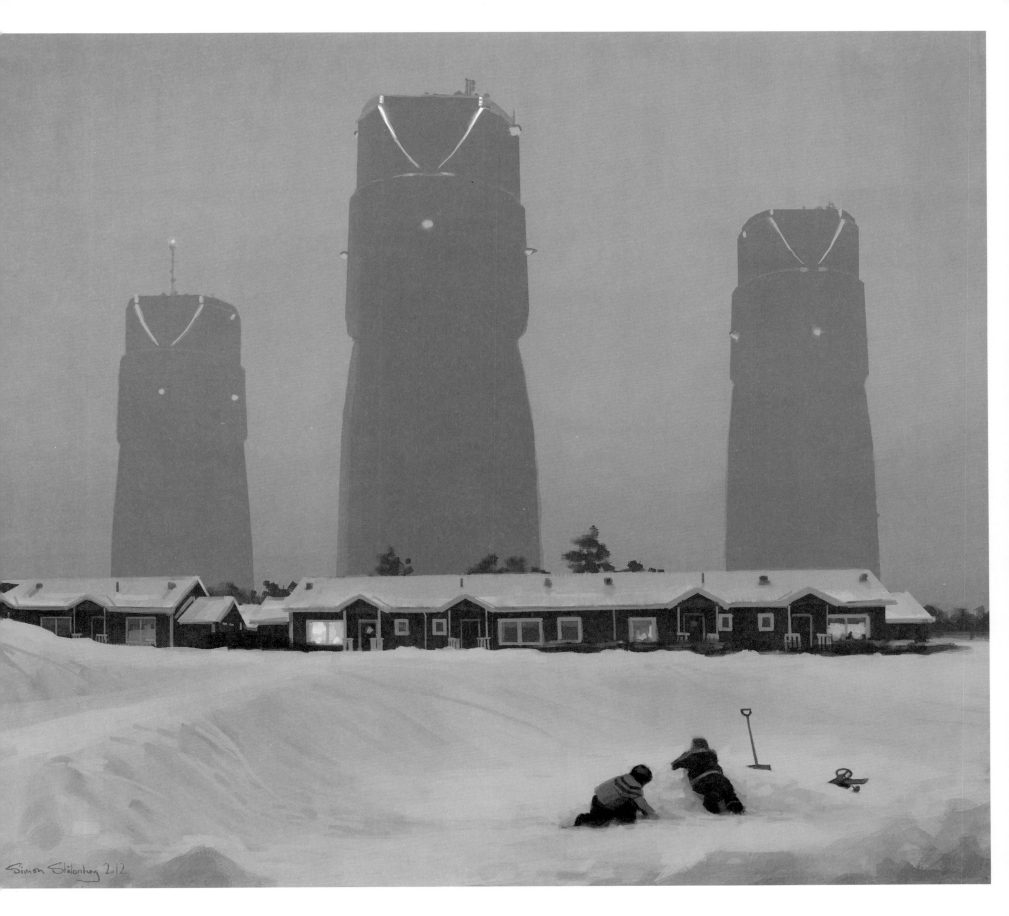

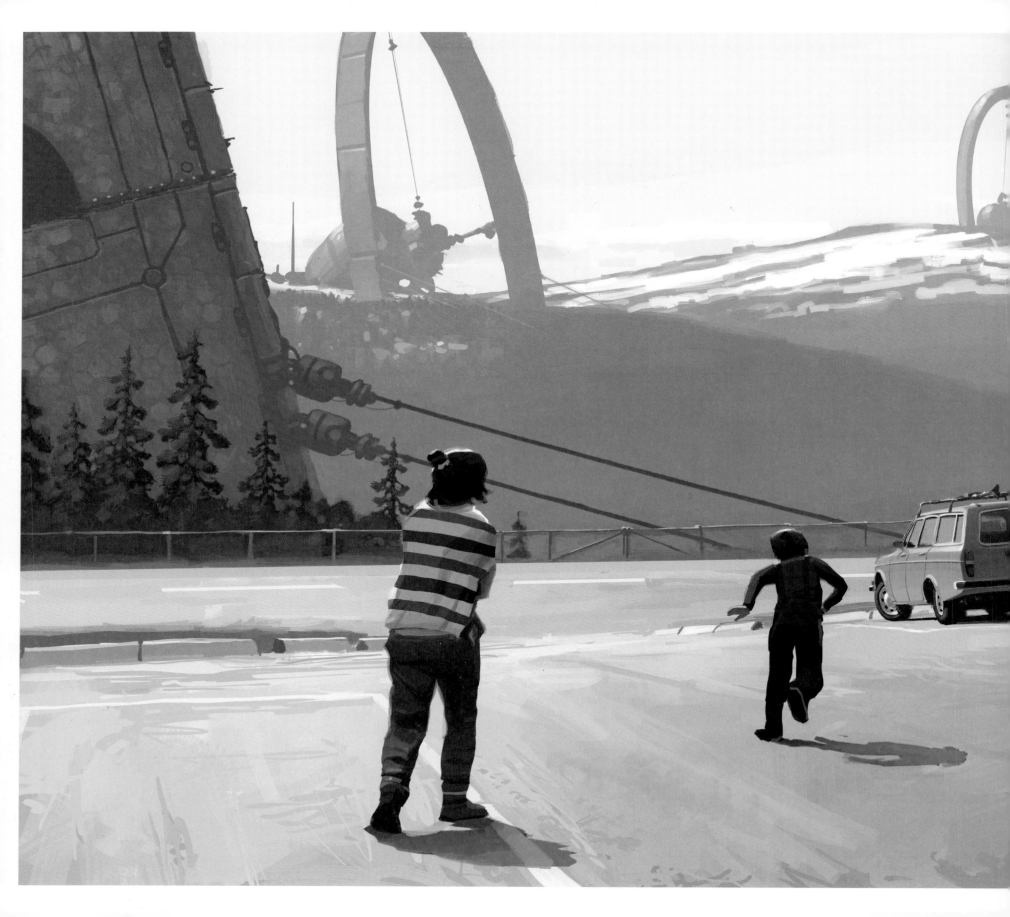

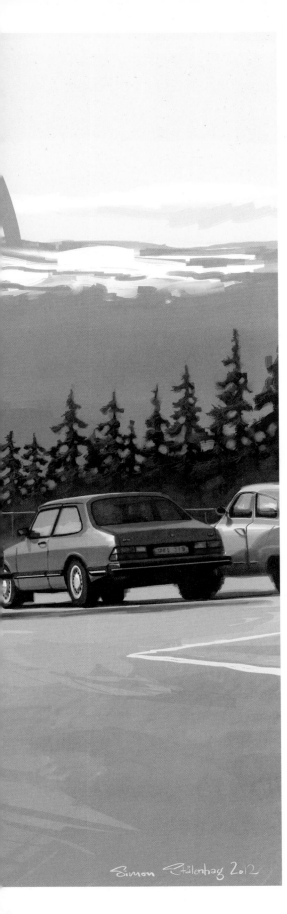

THE ARCH TOWERS AT KLÖVSJÖ

We went skiing in Härjedalen during Easter break in 1991. On the way there my father told us about the amazing arch towers we would see when we arrived. He spoke in awe about these monuments to Swedish engineering. They had been constructed to transform the force of downdrafts into electricity, and would enhance the effect a thousandfold using the magnetic charge of the bedrock. We could glimpse the towers beyond the peaks at the horizon an hour before we arrived. My stomach fluttered every time we drove up a hill because I anticipated seeing how much bigger the towers had grown on the other side of the crest.

One night, in the caravan, a strange noise woke me up. I sat up, wide awake, and listened. All around me in the dark I could hear the others sleeping, but there was something else there as well. Distant howls, almost like screaming, penetrated the thin walls of the RV. I looked out the window toward the campground and, between some pines, I saw the valley and one of the arch towers. Small flares of light swarmed above the mounting around the tower. They danced in the cold air, emitting soft siren calls that echoed in the valley. I was scared and woke my father up. He explained that the flares were ball lightning that leapt between the steel of the tower and the iron ore in the ground, created by a lingering charge of static electricity, and that it was completely safe at this distance. I didn't really understand what it meant, but it was comforting so I went back to sleep.

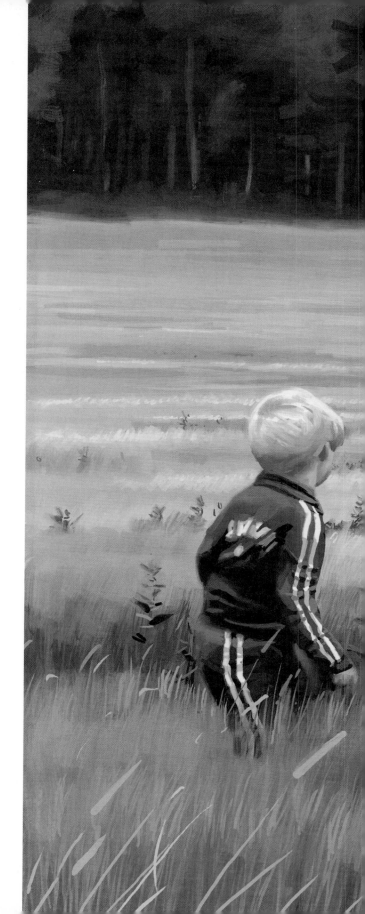

THE REMOTE GLOVE

As the robot thundered across the rye field towards the police van, I realized a line had been crossed, and that it had been crossed many hours earlier that day. Maybe it happened when we broke into the warehouse down in Sätuna, when Olof dragged out that peculiar backpack. Strange that I didn't notice it then—when Olof slipped his hand into the big glove and the Thing under the tarp came to life. Or did it happen even earlier, when we ran away from home before lunch? Summer days are an intense series of events; it's hard to remember how it all connects. Maybe we passed the line that morning, when we poured baking soda and flour in the kiddie pool. The fact that it was a bad thing to do became readily apparent from Olof's father's reaction. He squeezed Olof's cheeks together and yelled right in his face. Afterwards we sat in Olof's room, rebellious, muttering about the injustice of life. Olof's eyes were red and he was massaging his cheeks. Then we snuck out unseen and disappeared. It's strange how such an event can feel so far away only hours later on the same day.

In that terrible instant in the rye field, the moments in Olof's room felt like a distant memory from another life. Some days are like jittery, malicious clockwork—sometimes things freeze mid-movement and we age several years in a few seconds.

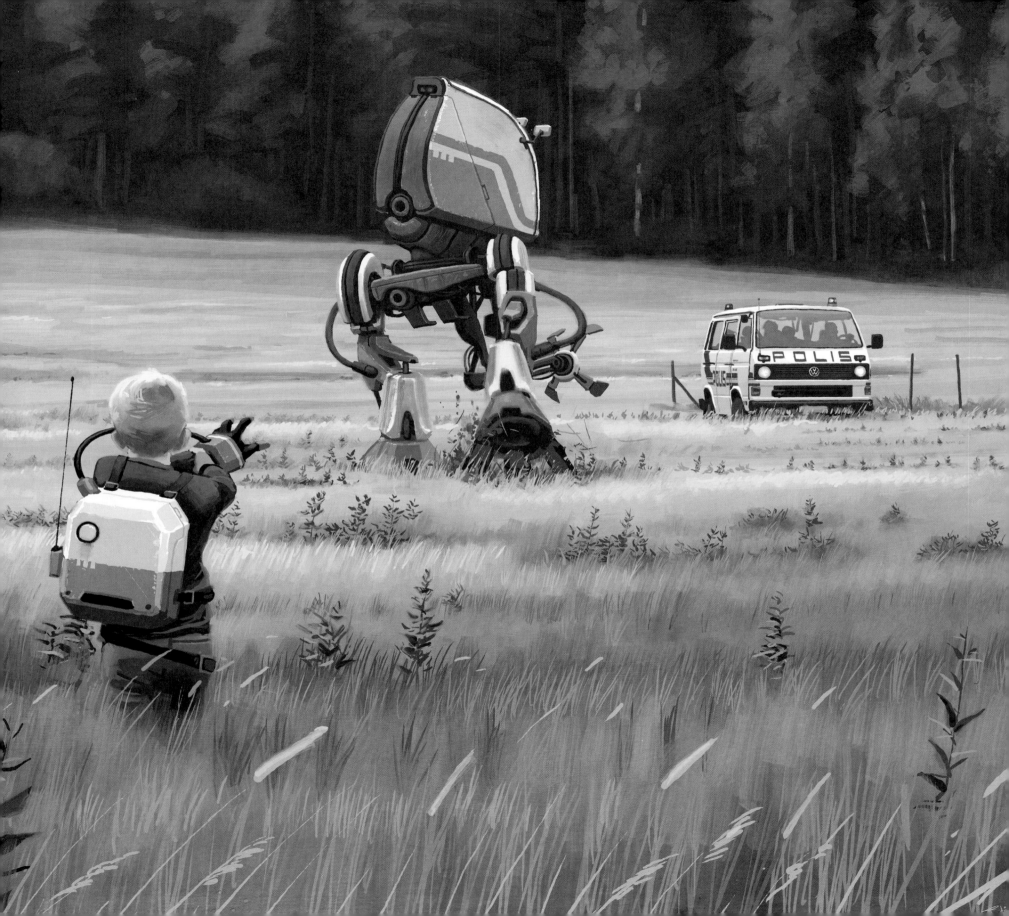

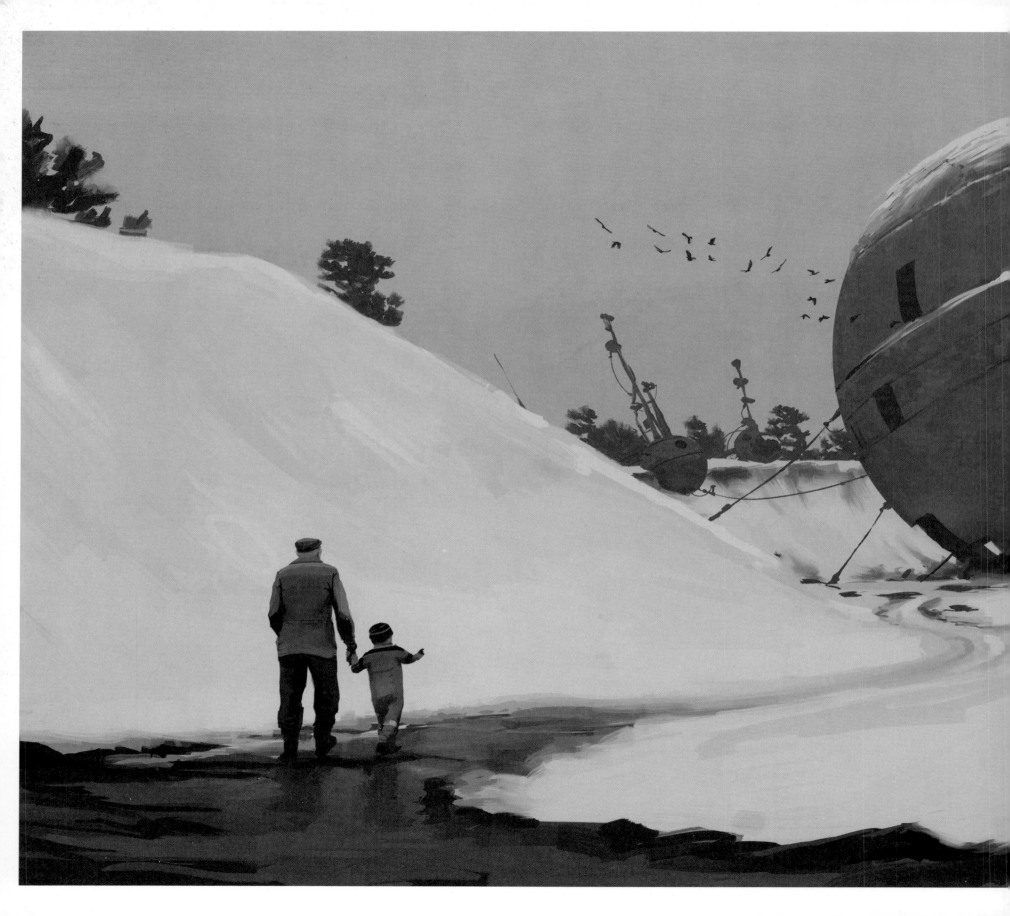

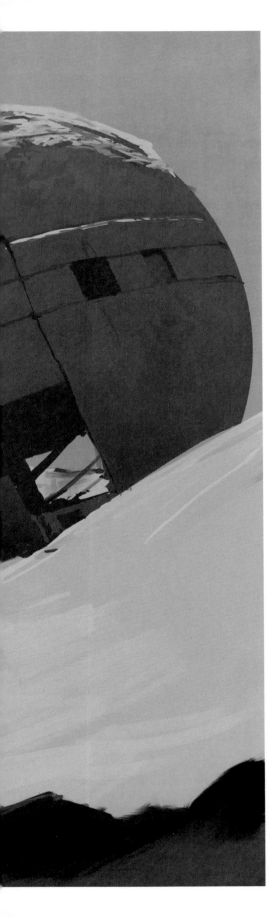

THE ECHO SPHERE

The mighty Uppsala Ridge once ran along the eastern side of Munsö. It was an esker, consisting of billions of tons of gravel and sand that had been deposited by ancient ice sheets. Centuries of gravel extraction had drained the esker and, at the end of the first half of the twentieth century, Munsö's eastern side had been transformed into a desert landscape. Then came the '60s and the construction of the Loop. The gravel pits became an assembly site and access point for the huge machines that were used. A lot of the machines and buildings were simply left there when construction was completed.

I have a vague memory of my grandfather taking me to Munsö once, when I was around four. I remember a big, hollow steel sphere. We walked into it. My voice echoed in there like I was in a church.

From Svartsjölandet we saw the scrap metal left behind sticking up over the ridge on the other side of the water. Beyond it all the mighty cooling towers of the Bona reactor reached for the sky. That other side tempted us all (every audacious Färingsö child made grand plans to go across the water and go on an expedition in Nordic Gobi), but there was one person whose fascination went far beyond that of everyone else.

Jenny had a dim-witted brother called Percy, and as soon as the ridge on Munsö was visible he went completely crazy. Jenny and I used to take Percy on walks, and when you least expected it he would blurt out a shrill "KISCHWOOOII-ING!" It sounded like he was trying to imitate a buzz saw. Then you knew he had seen Munsö for a split second behind the trees—Percy's head was like a compass needle pointing that way.

The sound he made was well-known. Sometimes when Jenny was about to read out loud in class, or present an assignment, you heard someone call out "KISCHWOOOIIING!" Morgan Pil, the class clown, based half his material on imitations of Percy.

Later that year, at the end of summer break, our fathers told us we were no longer little children. Real life was about to begin. We celebrated this by borrowing Olof's father's boat without permission, and we rowed across the water to Nordic Gobi on Munsö.

The echo sphere lay there in the gravel pit. A faint tune hummed from within the sphere when the wind resonated between the steel walls. Kalle and Olof immediately ran inside and started shouting to test the echo. A pair of nervous ospreys wheeled above the sphere. I remained outside, reminded of that first day there with my grandfather. Thinking back on it now I realize that this is probably my first memory of experiencing nostalgia. Odd; a summer's day and three nine-year-olds, one of whom was stopped in the middle of playing by a childhood memory.

Afterwards, we went swimming in the emerald green ponds, of course. Olof used heavy round stones to weigh himself down and walked along the bottom of a pond like an astronaut.

I swam away from the others quietly and rounded a headland. Beyond it the gravel pit opened up and a desert of abandoned machines stretched towards the horizon like an elephant graveyard. Something floated to the surface: not in the water, but within me. I whispered quietly, "Kischwoing."

The silence was broken by Olof's cry:

"I'VE FOUND A CAR WRECK!"

I quickly went back to join the others.

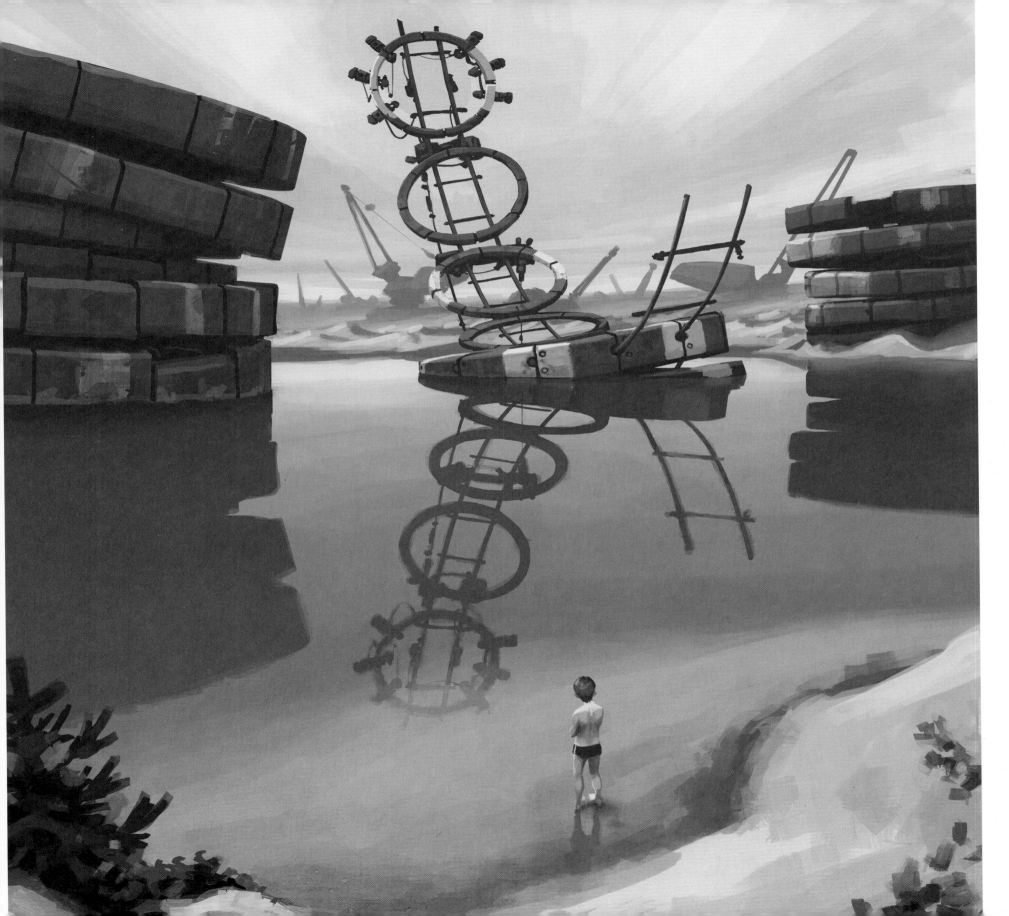

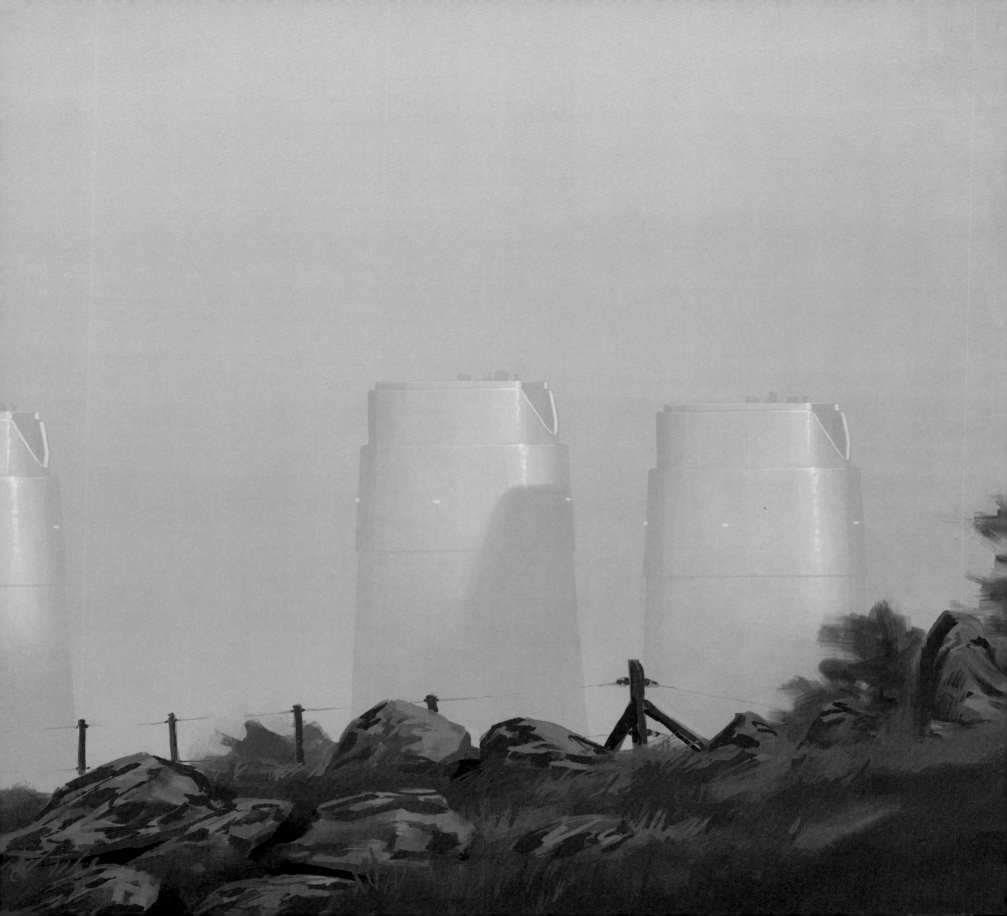

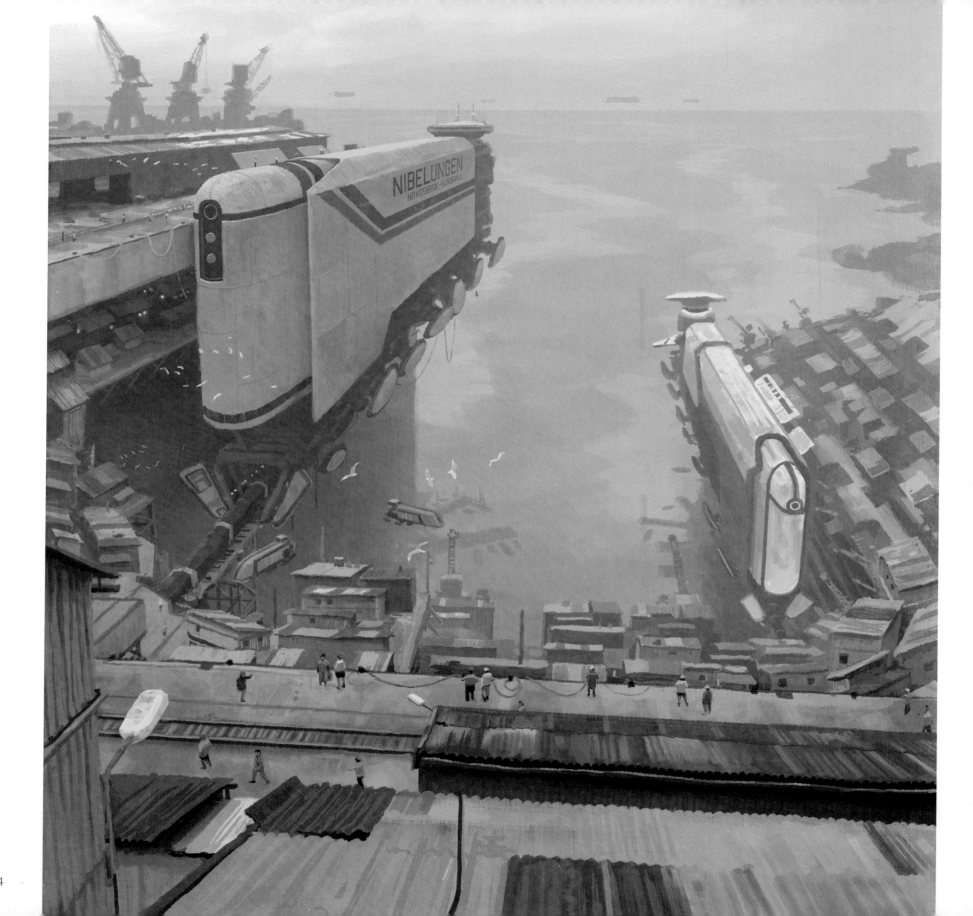

THE MAGNETRINE DISCS AT SPÅNVIKEN

Nowadays, during the winter months when the trees are bare, with good luck and an effort of will you might be able to see an old, rusted valve from a pump station rise above the water in the reeds off Göholmen's northern point. It really doesn't look like much of anything, but up until sometime in the mid '90s the awe-inspiring outlines of massive magnetrine discs rose from the water in the middle of Spånviken. These were not the regular small-diameter discs you could see under Riksenergi's locomotive ships. The diameter of the biggest disc in Spånviken is supposed to have been over 30 meters. They were constructed to carry 10,000-ton Gauss freighters along the tundra route to the north. The discs in Spånviken fascinated us; we drifted off, and in our imaginations we were on adventures in the tundra—maybe as captains of a Gauss freighter in distress, hijacked by barbarian pirates from Norilsk.

The magnetrine discs in Spånviken were remnants from an age that the Mälarö children of my generation never experienced. Up until 1979 there was a factory on Dävensö that built and repaired magnetrine discs. After the Ural Crisis in the '70s, Swedish ore exports declined and demand for magnetrine technology dwindled, and the Dävensö plant had to close. The employees were fired or transferred, the inventory was sold, and the plant itself was left to be reclaimed by nature.

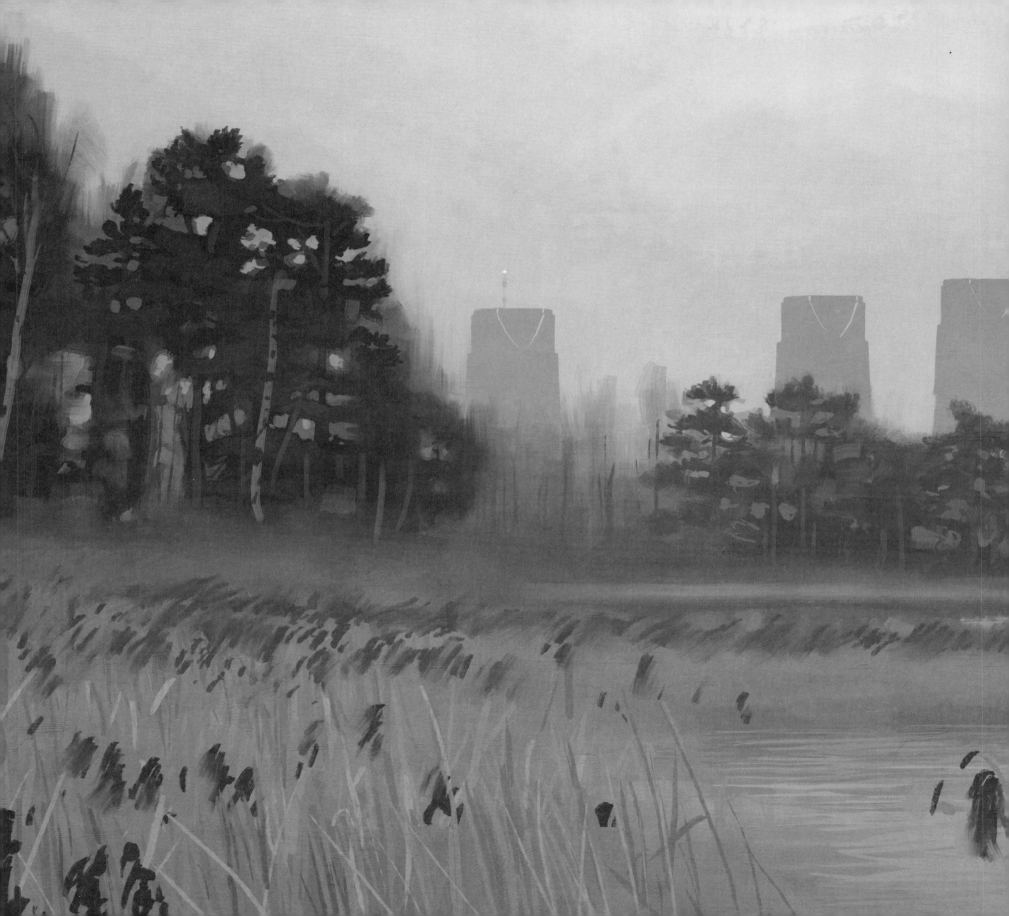

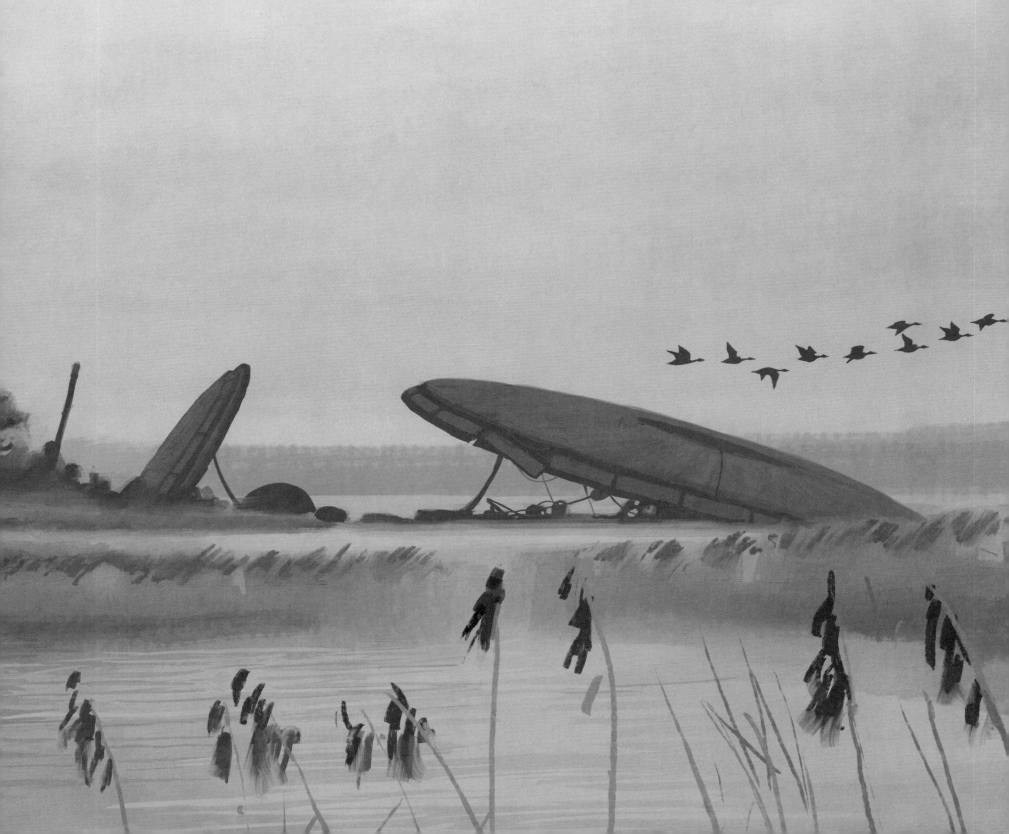

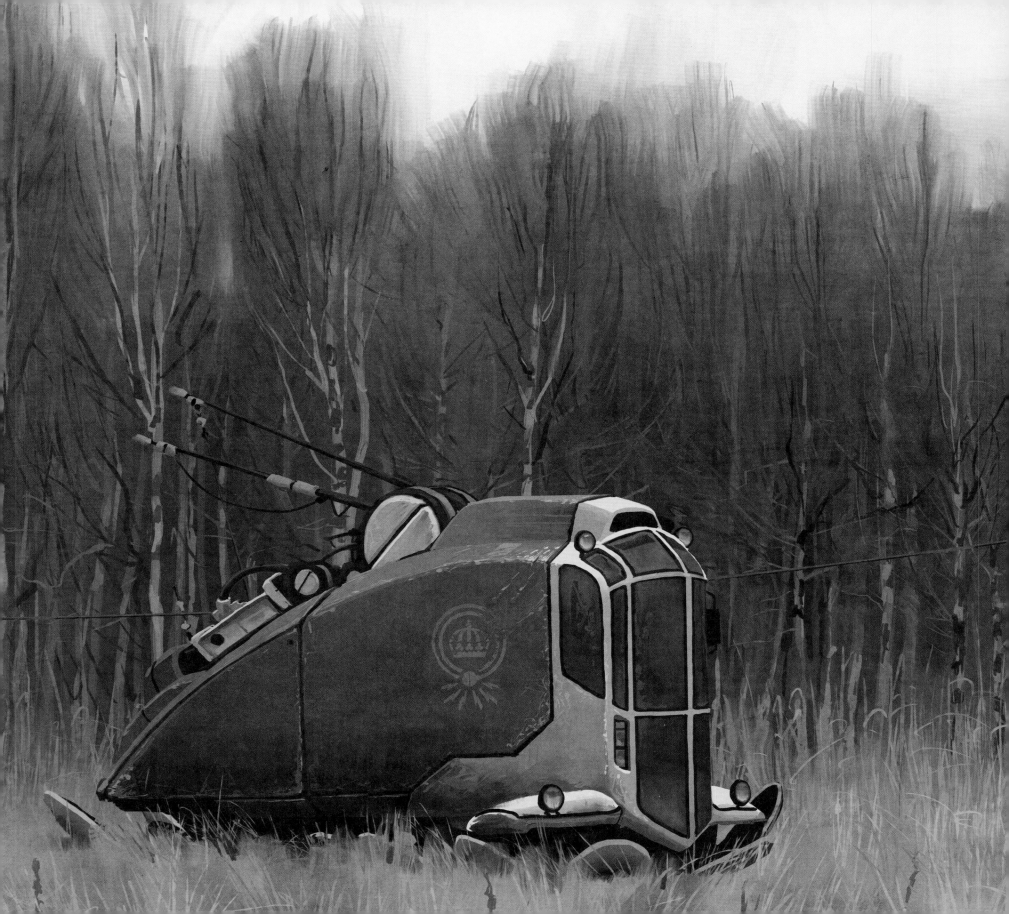

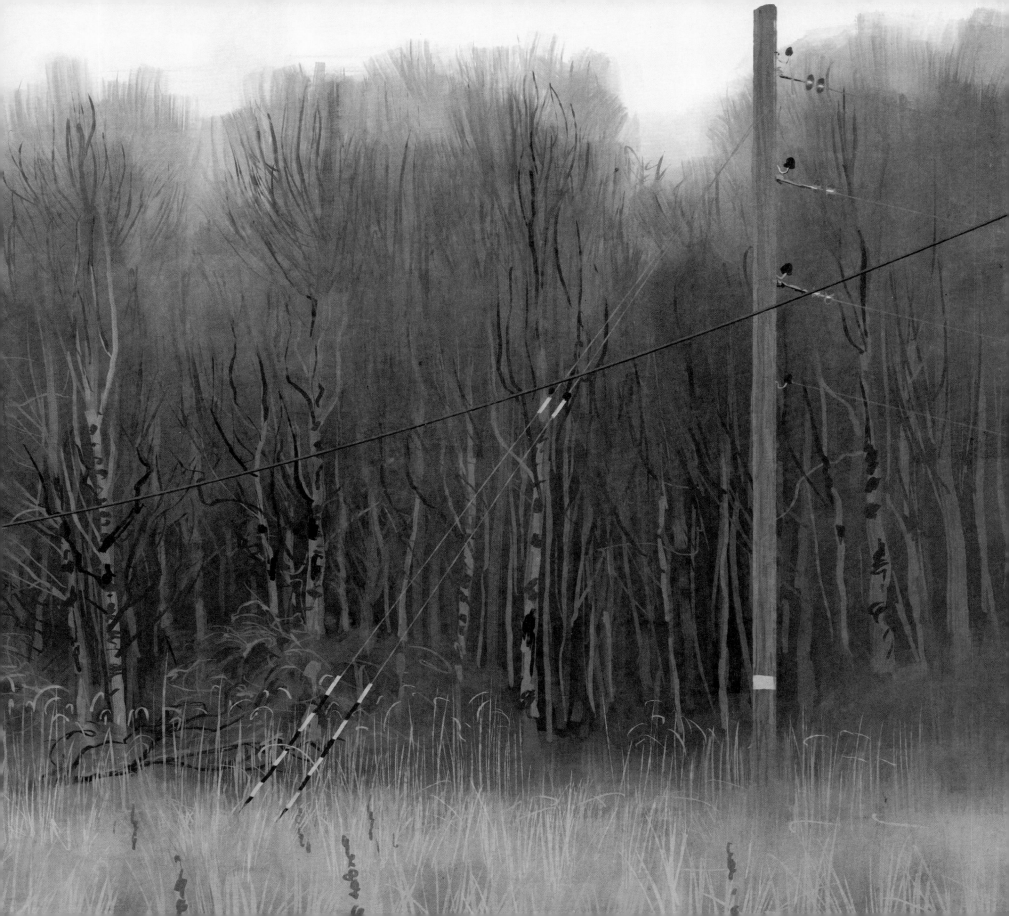

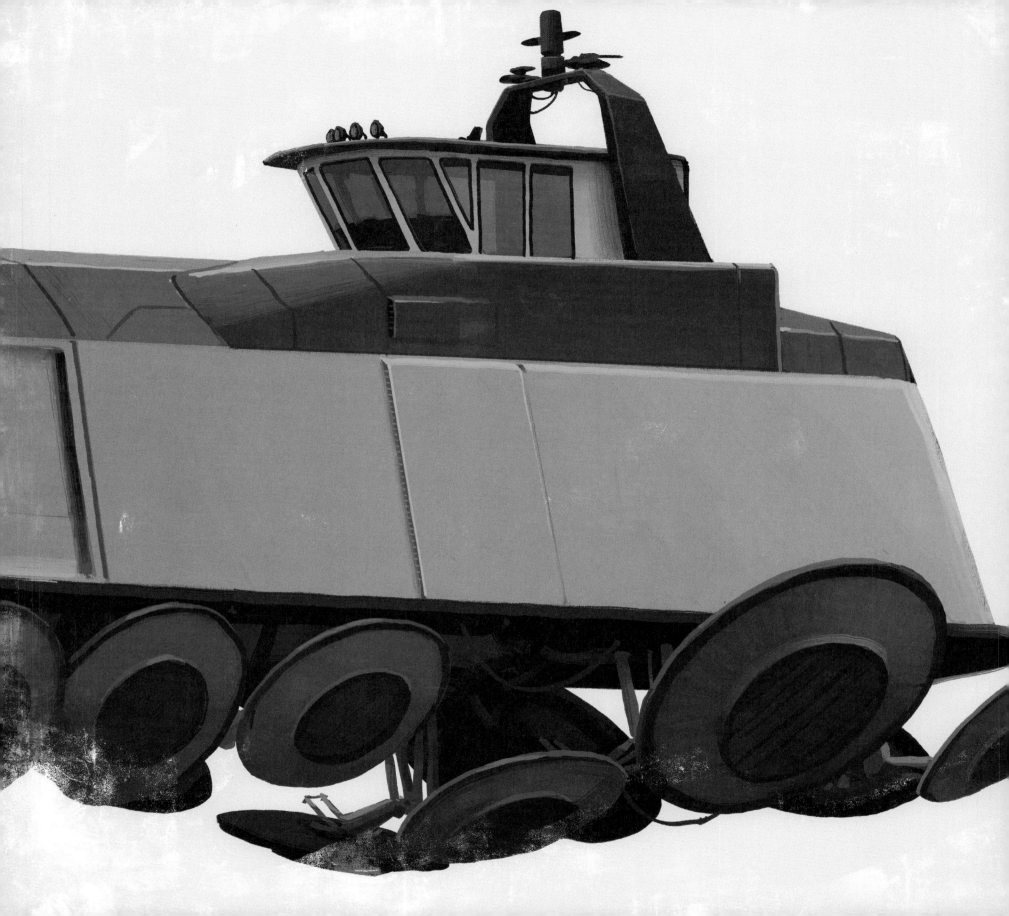

Magnetrine flight– How it works:

1. **The Earth's magnetic field.** The interaction between the Earth's rotation and the movement of its liquid core creates a magnetic field around our planet.

You could say the whole planet works like a gigantic magnet. The field is strongest around the poles, where the field's bearing angle is vertical, and weakest along the equator, where it is horizontal. The buoyant force is negative towards the south pole, and the major transport routes are located to the north, and not to the south, because of these properties of the magnetic field. The strength of the magnetic field is measured in a unit called "Gauss."

2. **The Magnetrine Effect.** In 1943, Mikhail Vorobyev stumbled upon what we today call the "Magnetrine Effect."

Vorobyev was an engineer in Russia during the Second World War, and he worked on developing a new kind of guidance system for long-range missiles. While experimenting with different types of gyroscopes, he discovered that if you enclosed a rapidly-rotating neodymium rod in a plate-shaped iron pod then the resulting device repels against the Earth's magnetic field. Vorobyev quickly realized what this implied and refined his design. Soon he had a disc with considerable lift; the first magnetrine disc was born.

3. **Safety.** Today, almost all locomotive ships use autocorrecting Sinter discs that adjust lift and angle the discs to match the local characteristics of the magnetic field.

Lieber-Alta's locomotive ships use discs that are powered by the most efficient and environmentally-friendly diesel engines on the market. In the unlikely event of an engine failure, a crash is practically impossible. Since the '60s, Sinter discs have had a so-called "float breaker," which ensures that the charge (and thus the lift) stays in the disc. A locomotive ship without power falls at a rate of three centimeters per week. A fifteen meter fall would take ten years!

4. **Power.** The effectiveness of magnetrine discs is phenomenal. Over the past thirty years Lieber-Alta has shipped a total of 300 billion tons, with an average of five million tons annually per Gauss freighter.

We are continually investing in new technologies, and the future looks bright. In 1988 our fleet will grow with twenty new Allistair ships, which will offer our customers a new level of effectiveness for mid-size ships. At the same time we will be launching our own logistics solution, TransAlta. Keep your eyes on the sky so you won't miss the innovations of the future!

LIEBER-ALTA
We make dreams take flight.

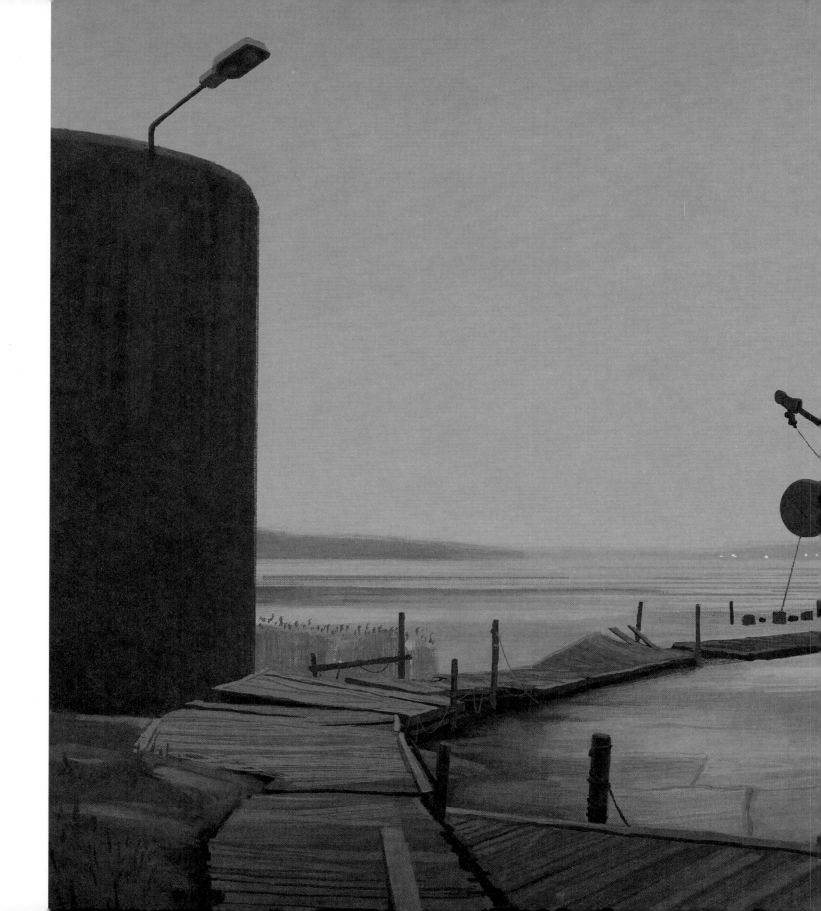

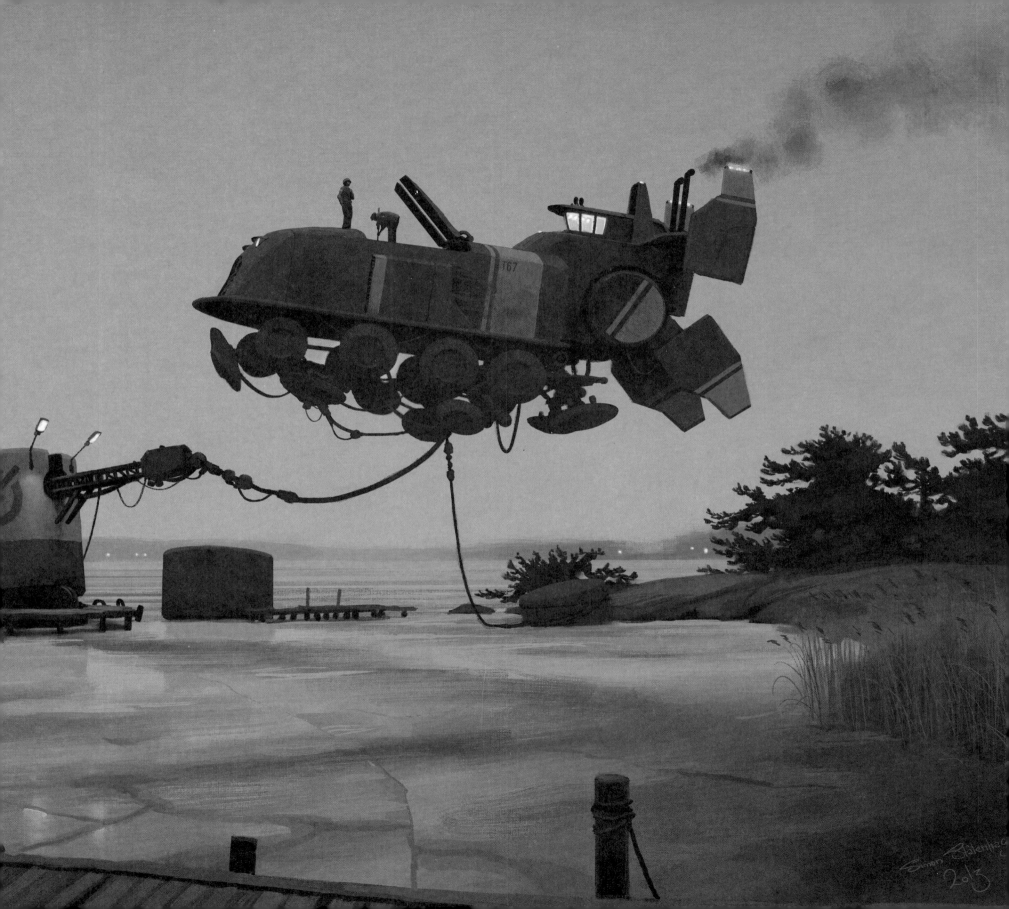

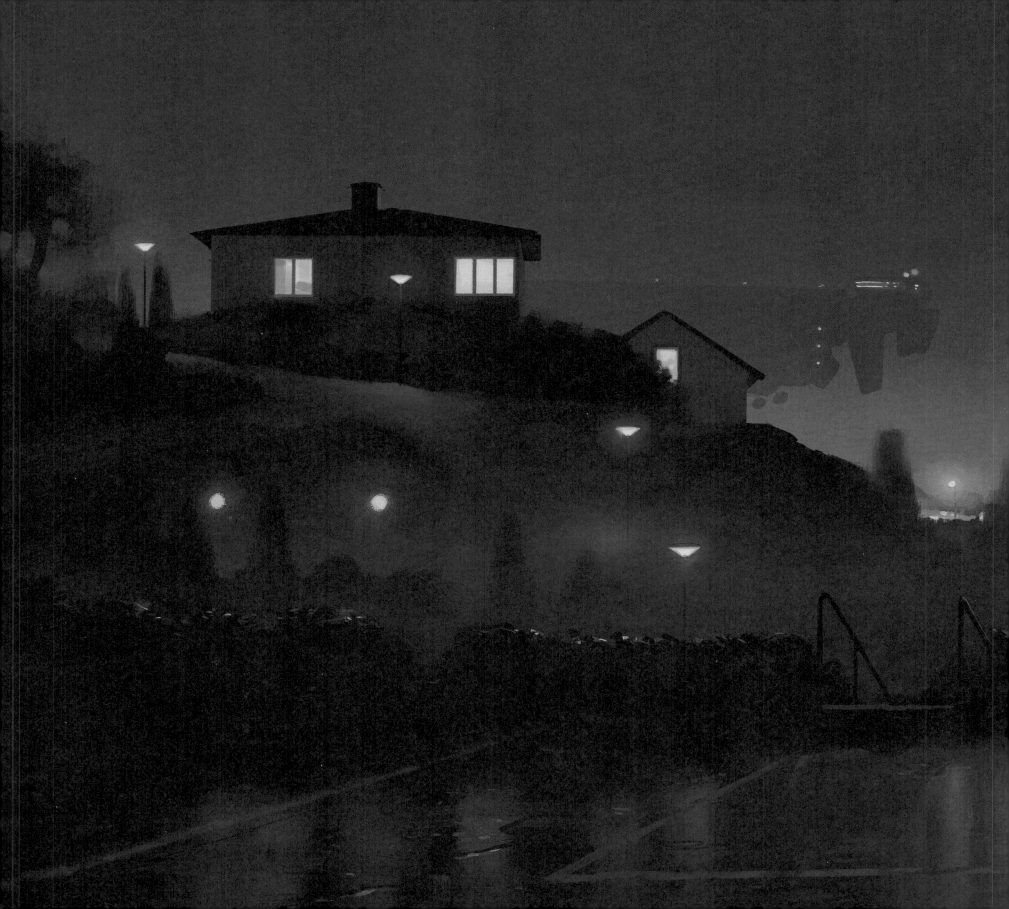

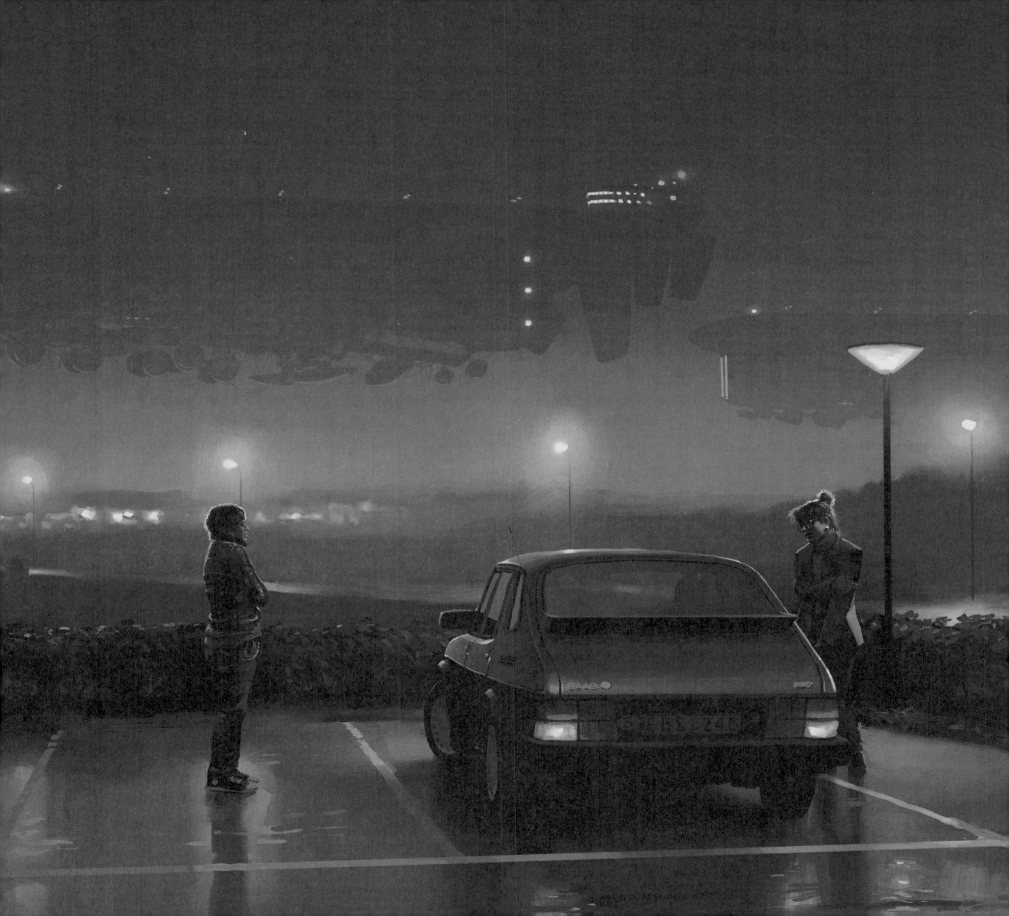

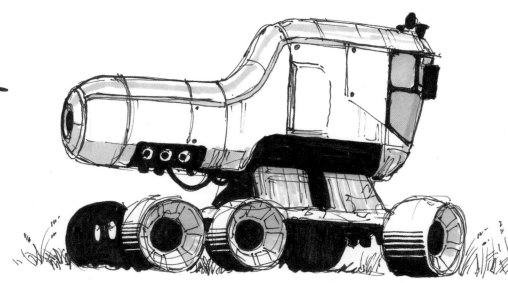

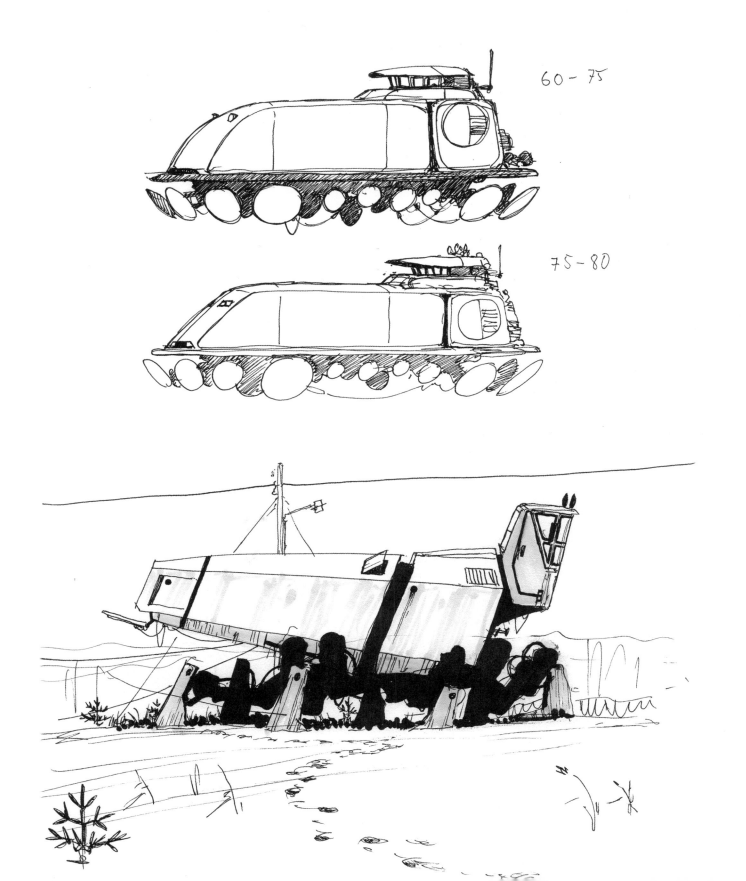

60-75

75-80

A DAY IN THE LIFE OF SERVICE ENGINEER MIKAEL WIRSÉN

Mikael lives in Stenhamra and has been working as a SERVICE ENGINEER for eleven years, since 1977. He says the best parts of the job are the freedom to plan his own routes and being out in nature a lot. He doesn't see much of the research down in the facility, but he thinks it's great to be part of something so groundbreaking.

Below is a description of a regular working day, at the end of February, for Mikael.

08:00
Mikael arrives at the garage in Tappström. Here he plans today's route. Today is Thursday so he will perform routine maintenance on all the COOLING MODULES, or "field hats" as they are commonly known. Mikael signs for his service vehicle and we head out on the roads.

09:00 – 11:45
Routine maintenance of all the cooling modules on the south side of Färingsö. First, all the COOLING RODS have to be replaced. The rods are the main heat-absorbing component in the module and can become extremely hot, sometimes as high as 6000 degrees Celsius. They have to be removed using the grip arm on the service vehicle, and then the COOLANT has to be replaced. All the hoses, brackets, and valves must be thoroughly examined, and any residue has to be cleaned off.
Since they are out in nature, the cooling modules have to be protected against the elements. RAIN COWLS, WOODPECKER SHIELDS, and LIGHTNING RODS need to be checked. Last but not least the timers of the cooling modules have to be reset. Mikael manages to service all nine modules on the south side of Färingsö before lunch.

11:45 LUNCH
Mikael eats lunch at the pizzeria in Stenhamra, where he is a popular regular. Care for a Vesuvio, Micke?

12:30
Mikael drives on towards Färentuna by way of Sånga Säby. On the stereo TOMMY NILSSON'S AND TONE NORUM'S "ALLT SOM JAG KÄNNER" is playing. Mikael is a true music lover and really appreciates that he can listen to music while working. Mikael sings along:
"VI HÅLLER VARANDRA, NÄR STORMARNA YR! JAG FINNS HÄR BREDVID DIG NÄR MORGONEN GRYR!" Färingsö has a rockstar passing through on tour!

12:45
At the service station in the Sätuna woods, Mikael leaves the spent cooling rods and fills up on SPARE PARTS. He takes the opportunity for a smoke break.

13:00 – 15:00 ROUTINE MAINTENANCE OF THE COOLING MODULES ON THE NORTH SIDE OF FÄRINGSÖ

Same procedure as before lunch.

15:00 – 17:00 REPLACING MAGNETRINES IN A FLUX WELL
Micke gets a call on his radio. The flux well in Ringnäs is sending error messages about high BOSON LEVELS. A possible cause might be a loose magnetrine clamp. Mikael has to go back to the service station in Sätuna to get the right equipment before he can handle the flux well. It turns out a SHRINK HOSE has come loose and impacted a magnetrine disc while spasming around in the well. Mikael has to don protective gear to handle the horrible hose. Mikael is quite the snake charmer!

With the flux well fixed, Mikael's working day is at an end and he aims his car back towards Tappström.

The sun peeks up over the horizon and LASSE HOLM'S "CANELLONI MACARONI" can be heard on the radio. Spring is almost here!

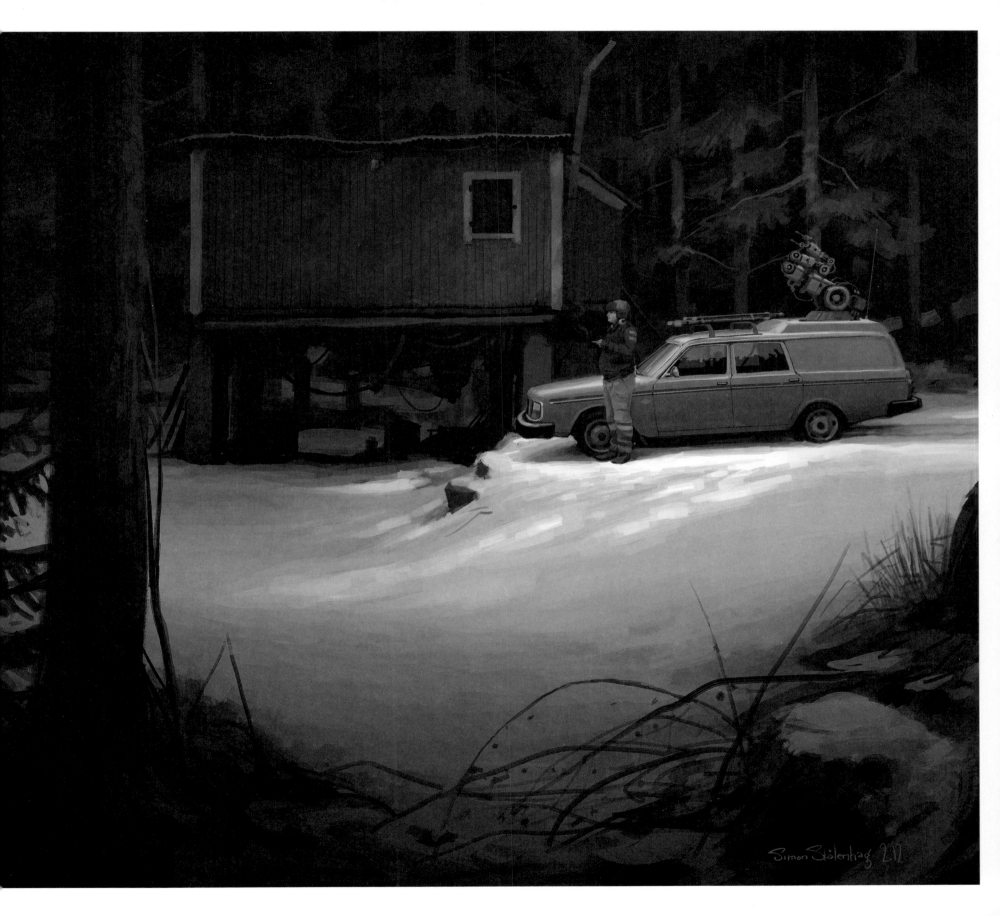

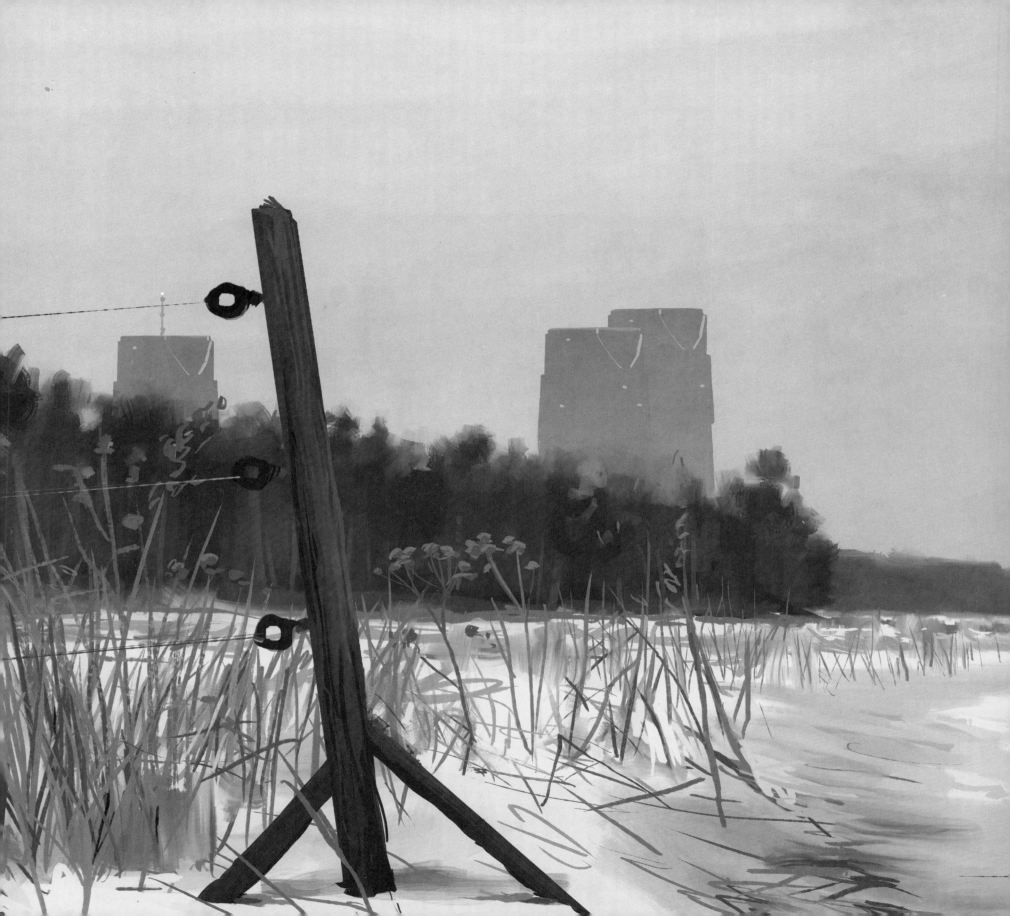

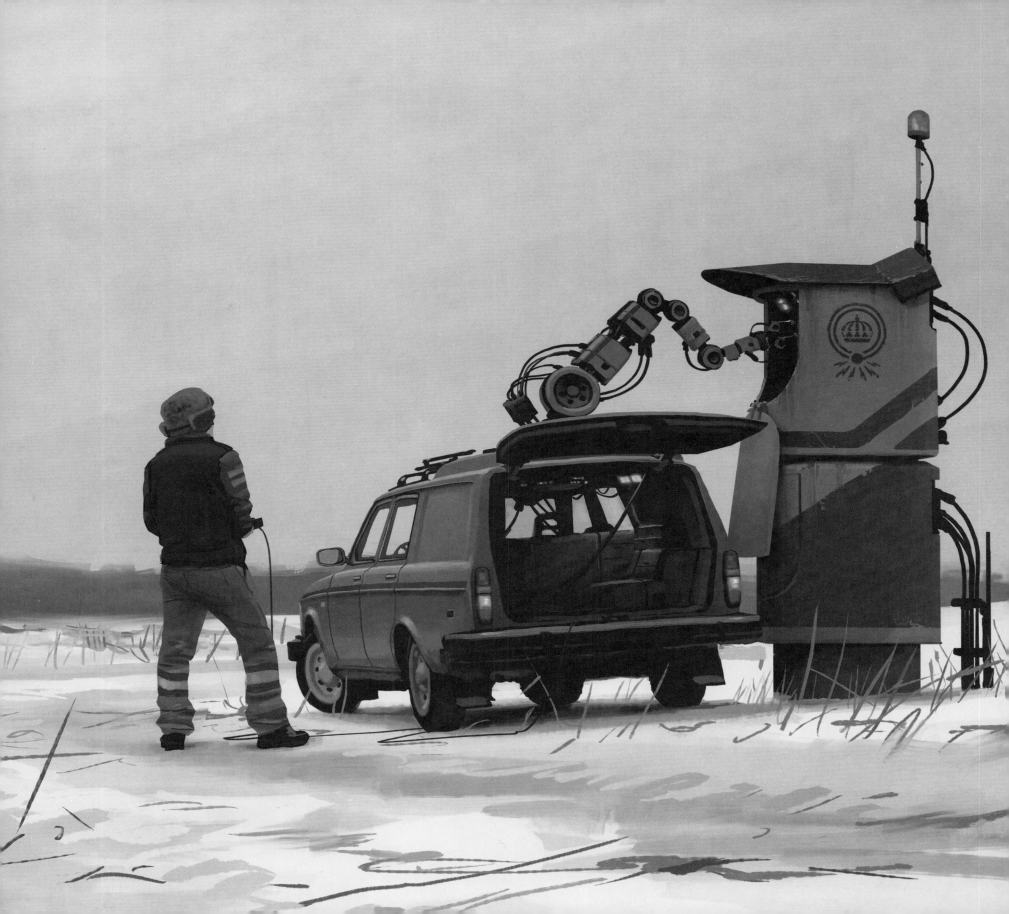

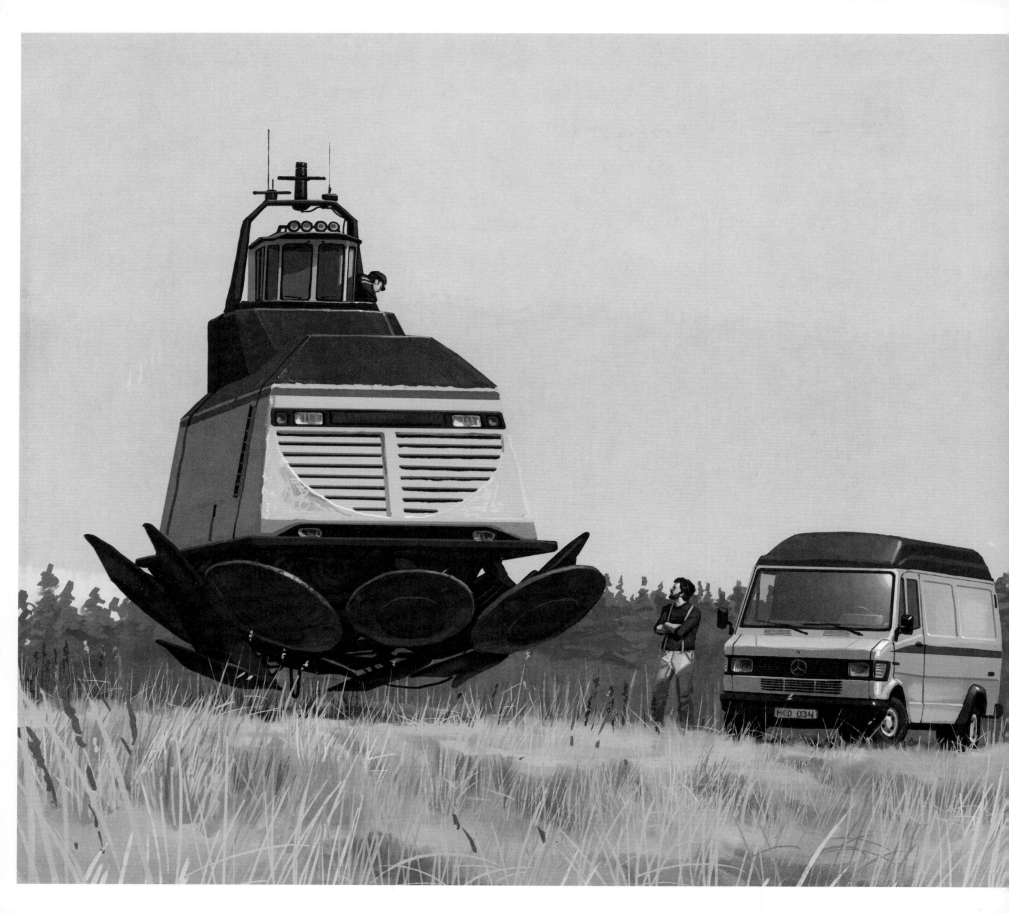

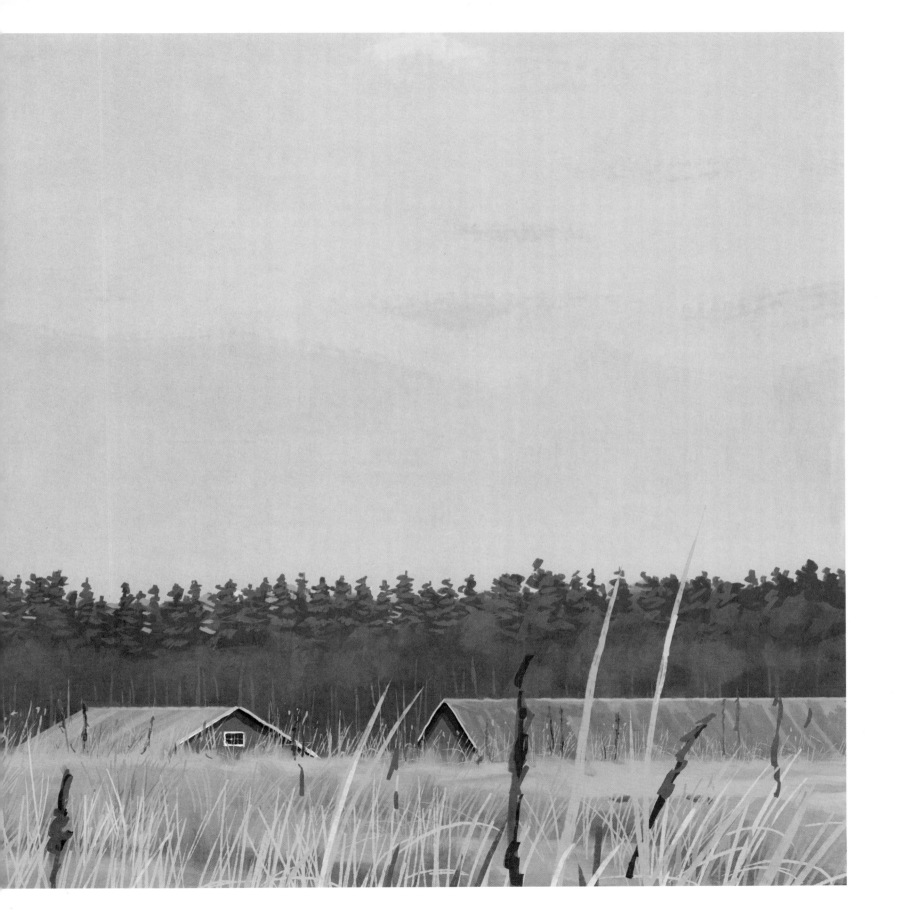

INVASIVE SPECIES

There was talk of prehistoric monsters in the woods. Eddies swirled in space-time, portals between our time and the past, in the wake of cosmic energies. A bridge had been created, allowing creatures from another time to travel to our world. Someone had found an empty lot covered in desert sand. A shoal of trilobites lay twitching on the roof of the school gymnasium. There were even rumors that the boy who lived with his mother in the lonely house, down by Lennartsvägen, had a pet dinosaur in the hen house.

I have a very clear memory of Olof and Kalle crossing the schoolyard on a hot day in September, their arms filled with ice cream boxes. They're both talking at once and their clothes are stained with melted ice cream. The story they told was phenomenal.

Kalle had woken up in the middle of the night, awakened by a sound he instantly recognized. The melodic signal of the ice cream truck echoed through the unusually warm September night. Odd—who wanted to buy ice cream in the middle of the night? Something really felt wrong.

The melody still echoed across the landscape in the morning, and Kalle called Olof. Together they went in search of the ice cream truck. They followed the sound all the way to the gravel pit. It was strong there.

They went into the tangled marsh at the far end of the gravel pit, and after a while they found it. The ice cream truck was wedged between two tree trunks, the cabin completely ripped open. The speaker dangled from the remains of the roof and still emitted its happy melody, and in the cargo space there was tons of ice cream that had begun to melt. Jackpot.

Kalle wiped his mouth and summarized their theories: "The only viable conclusion…"—and I swear he stopped to push up his glasses—"…is that two giant carnivorous *Gorgosaurus libratus* were drawn to the melody, and then attacked the ice cream truck."

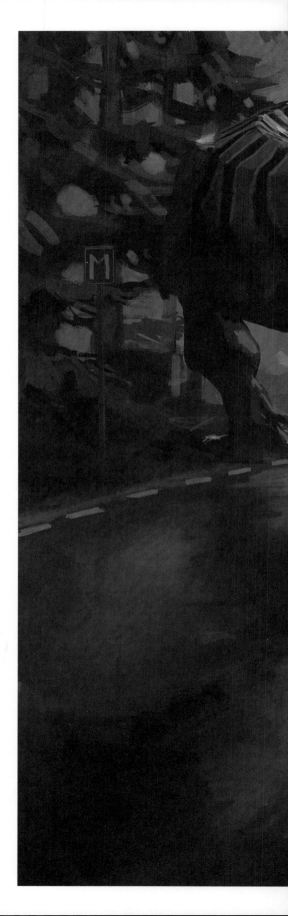

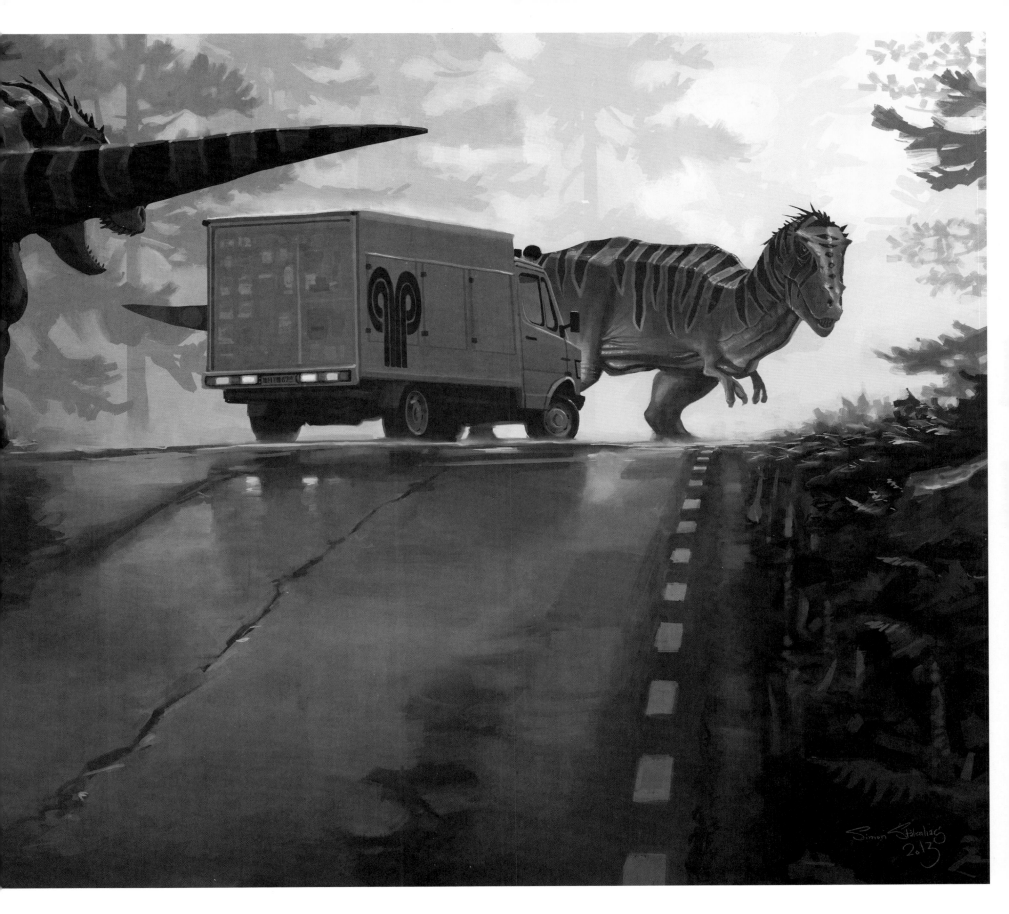

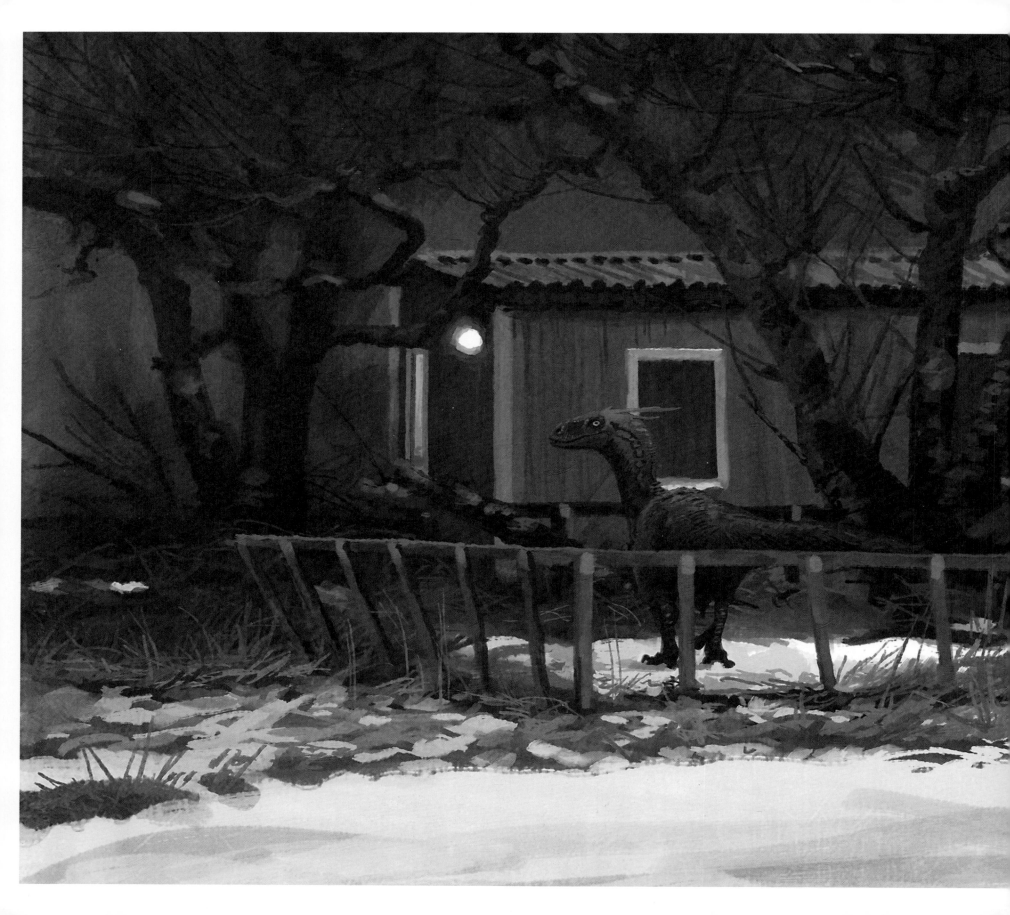

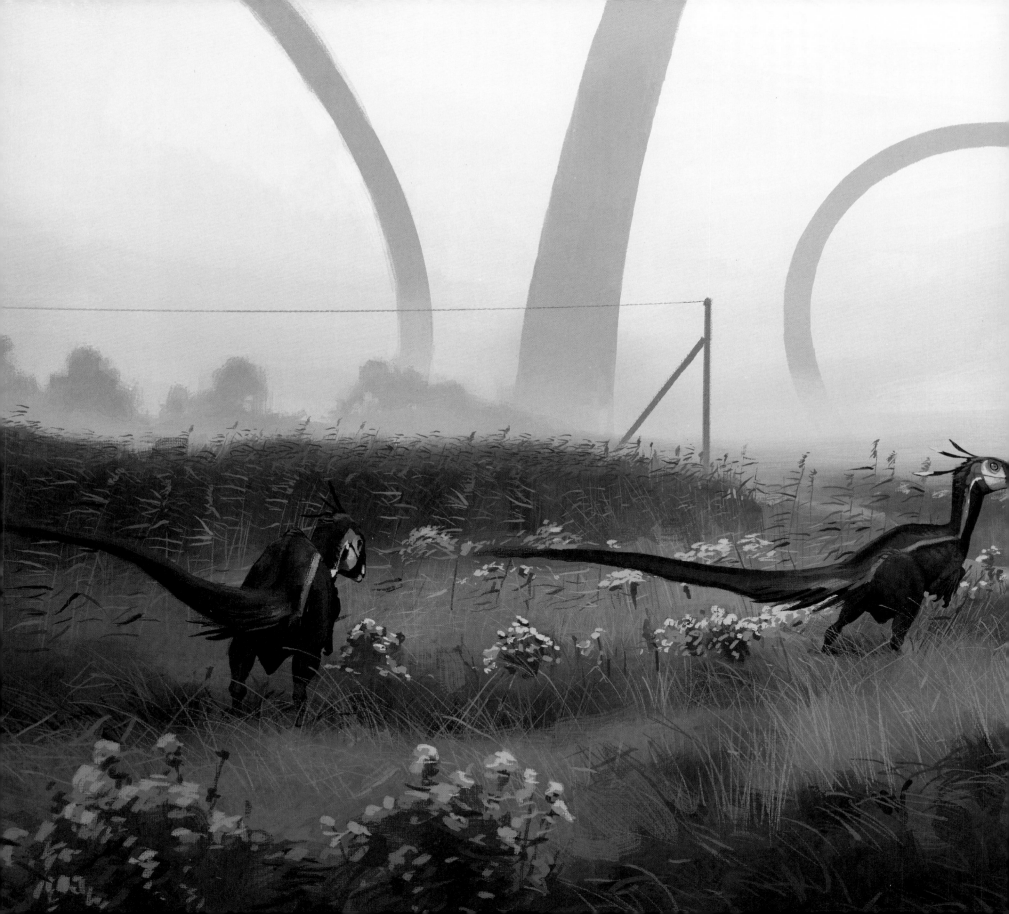

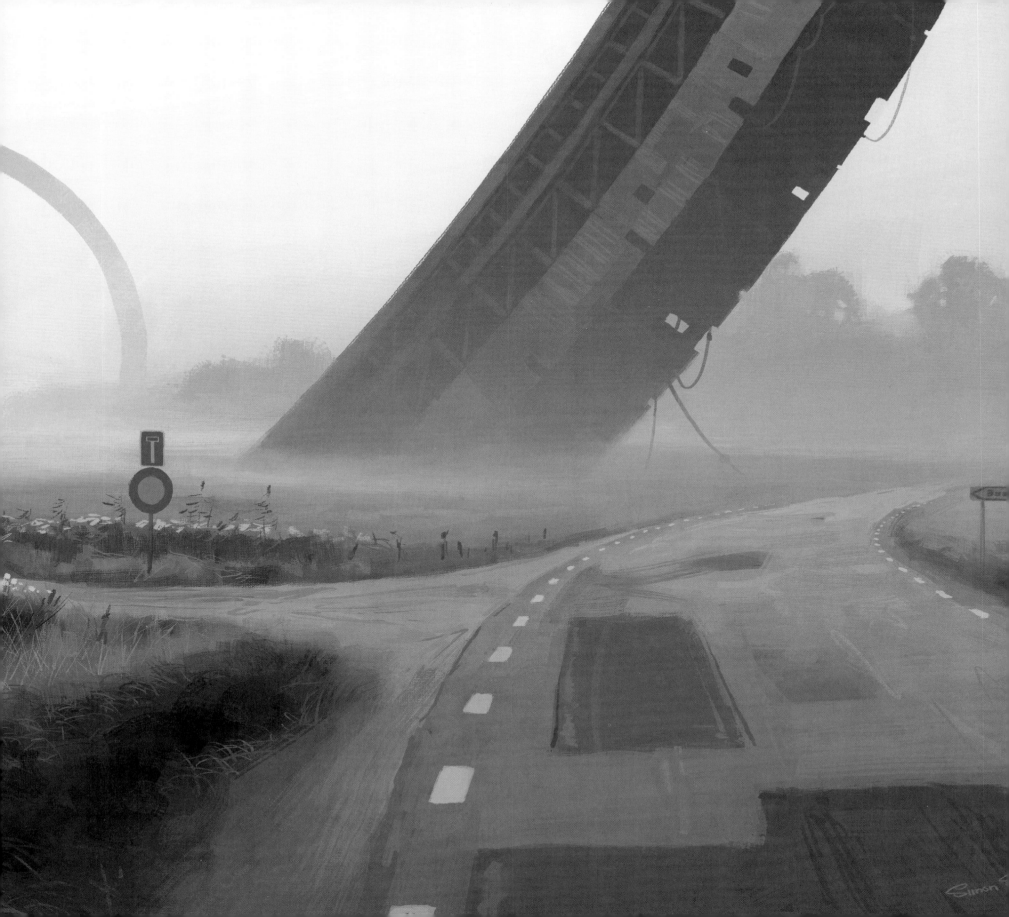

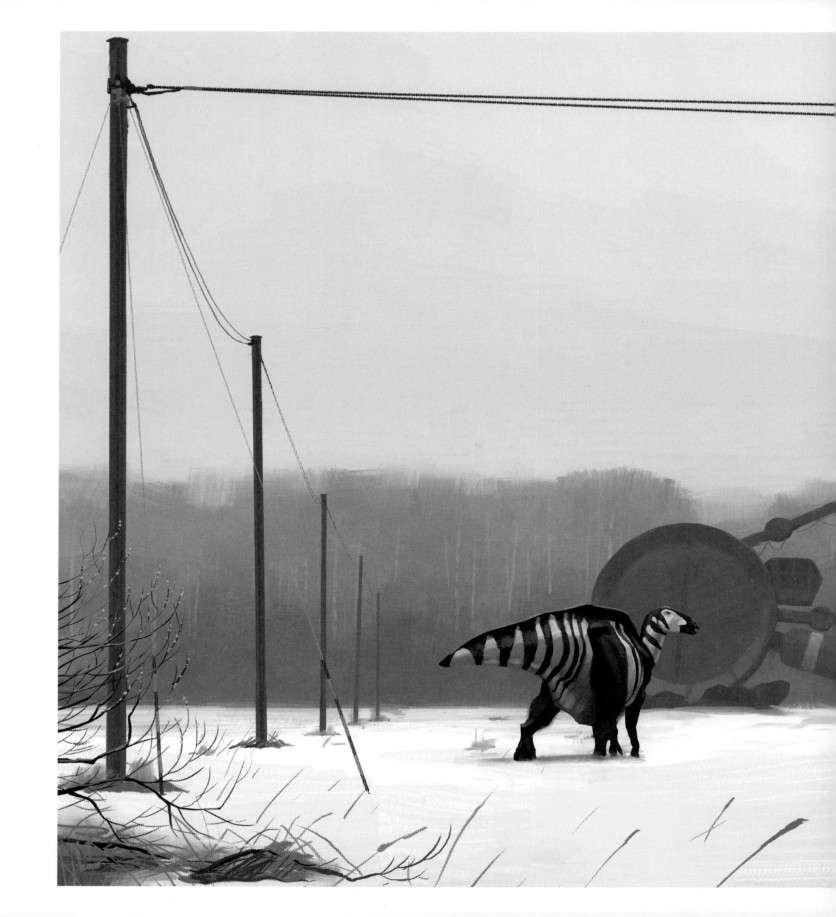

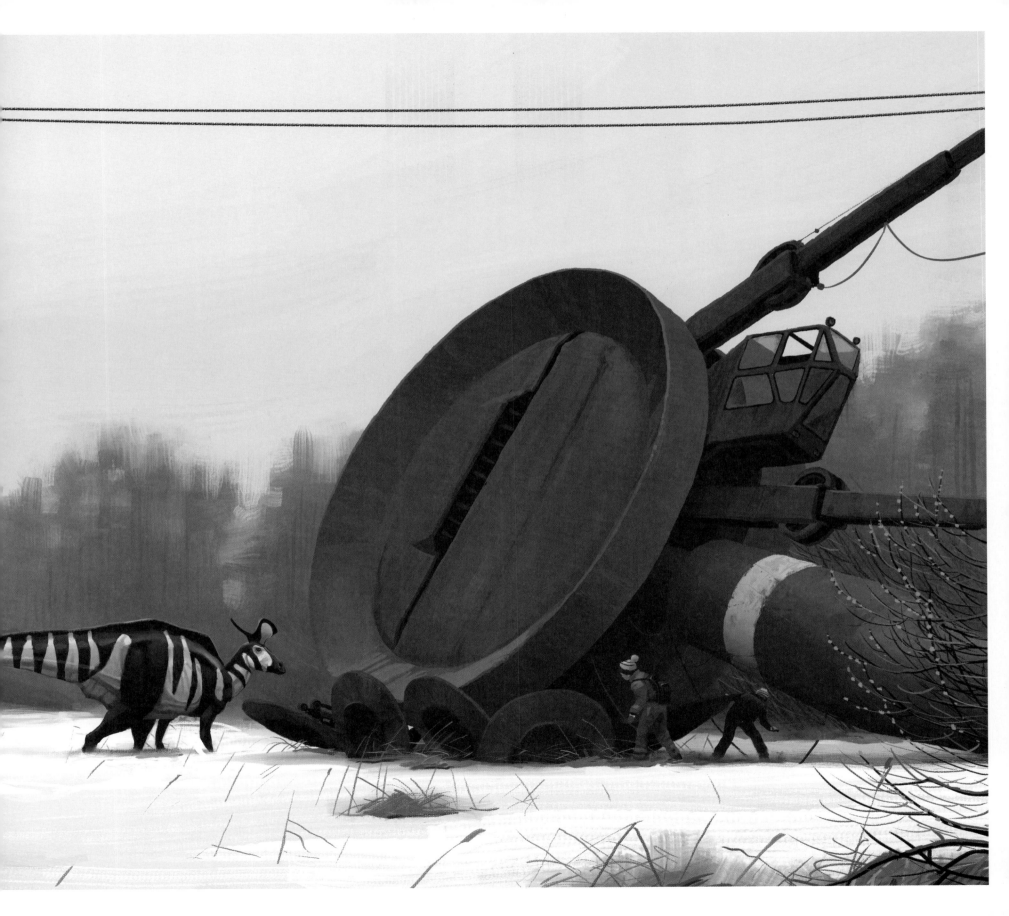

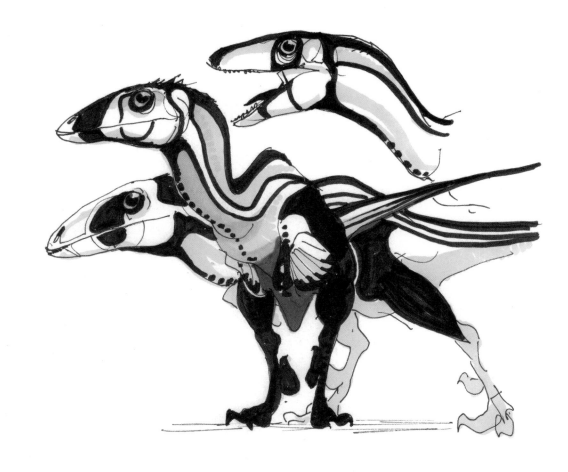

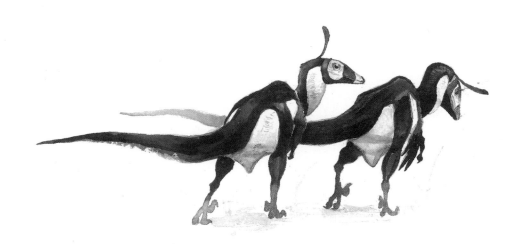

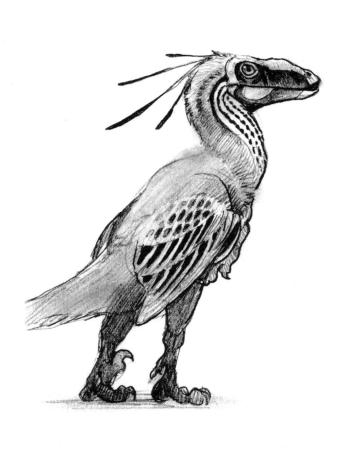

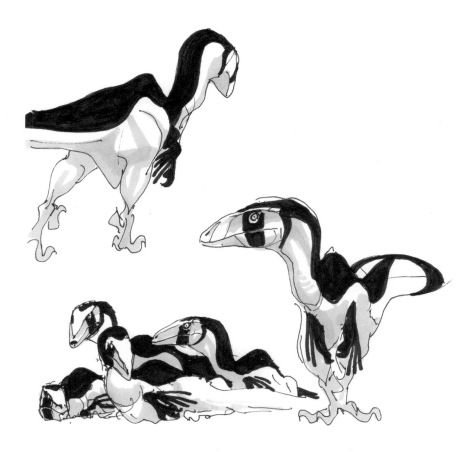

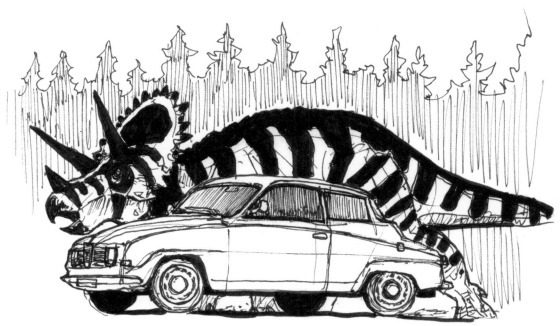

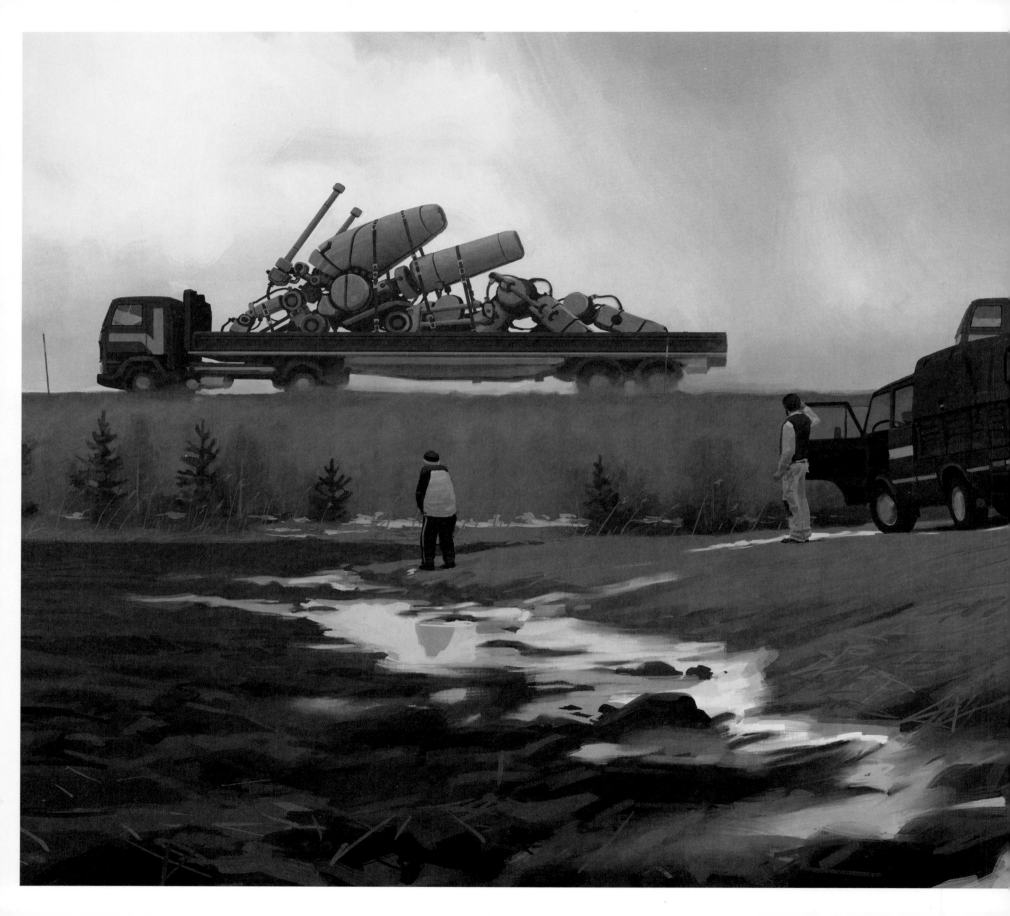

ROBOT TRANSPORT

Balanced machines had a major breakthrough in the '60s when Iwasaki presented the first functional artificial nervous system. Suddenly, our machines were bestowed balance and grace previously reserved for biological organisms. Of course, wheeled vehicles were still superior on the roads and in civilian society, but in forestry, mining, warfare, planetary exploration—every single field of operations where there were no roads—robots were a revolution.

Thanks to the Loop, Mälaröarna had become a robot paradise and we knew all the makes and models.

Riksenergi had an impressive array of robots at their disposal. Paarhufer's and Maltemann's four-legged models were used for service work in open terrain. Two-legged unmanned units were used in high-risk areas within the Loop itself. Two unmanned, completely autonomous, two-legged robots, specially designed for Riksenergi by Swedish ALTA, patrolled down by Jäsängen. They were designated ABM100 but were usually called the "Fire Watchers."

All this was fascinating of course, but what enthralled us most were the machines that moved inside FOA's facility on Munsö. Several secret projects were carried out there. Research was focused on biomechanics, evolutionary robotics, and cybernetics. Rumor had it they were trying to create machines that were able to feel and reason. Apparently they made progress; they were unable to stop prototypes escaping on several occasions.

THE ESCAPEE

It stood under the oak tree in the yard—an oily, sad little tin-can thing, its head partially entangled in some sort of canvas cover. It had discovered me and stood perfectly still, its head fixed in my direction. As I approached, it rocked nervously to and fro where it stood. It flinched, rustling its wiring, each time the snow crunched underneath my boots. Soon I was close, so close I could reach the cover hanging from one of its lenses. I leaned forward, managed to get hold of the canvas, and yanked it off. The optics underneath it quickly focused. It was marked FOA on the side, which meant this was an escapee from Munsö. Then our front door rattled, and with three quick bounds the robot was gone. The door opened and there, on the steps, stood my father.

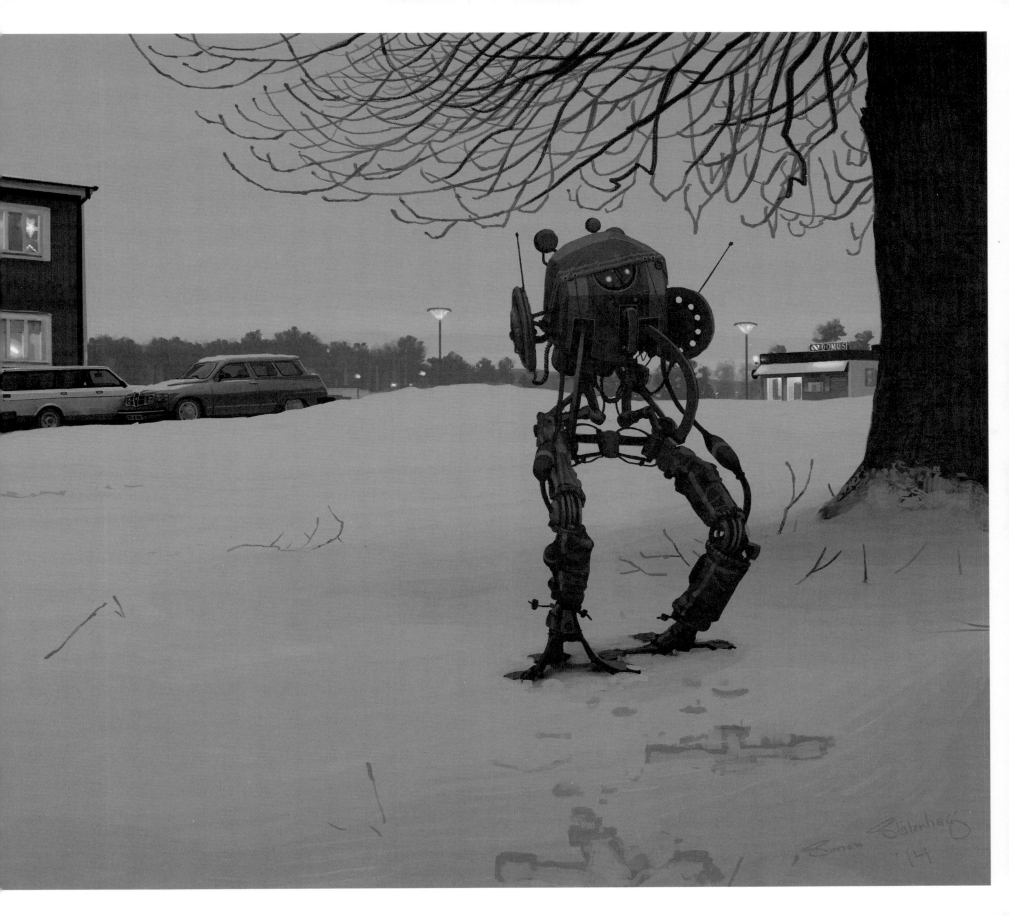

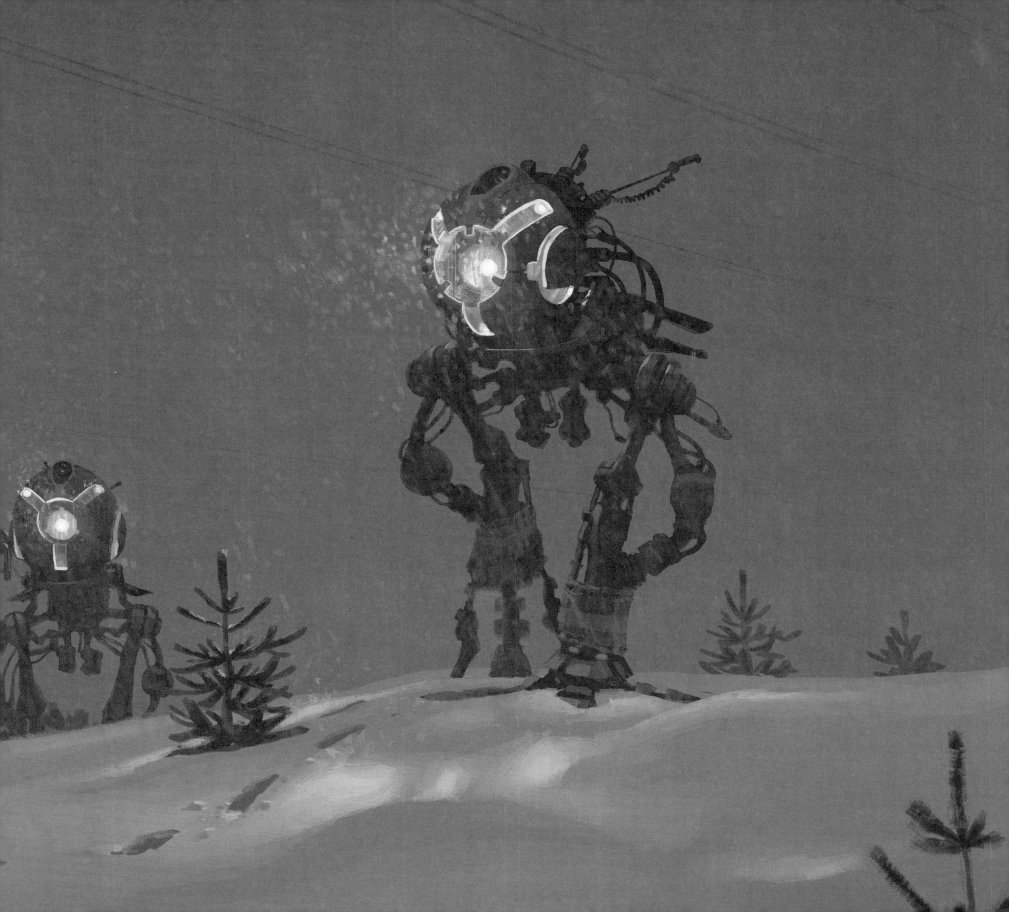

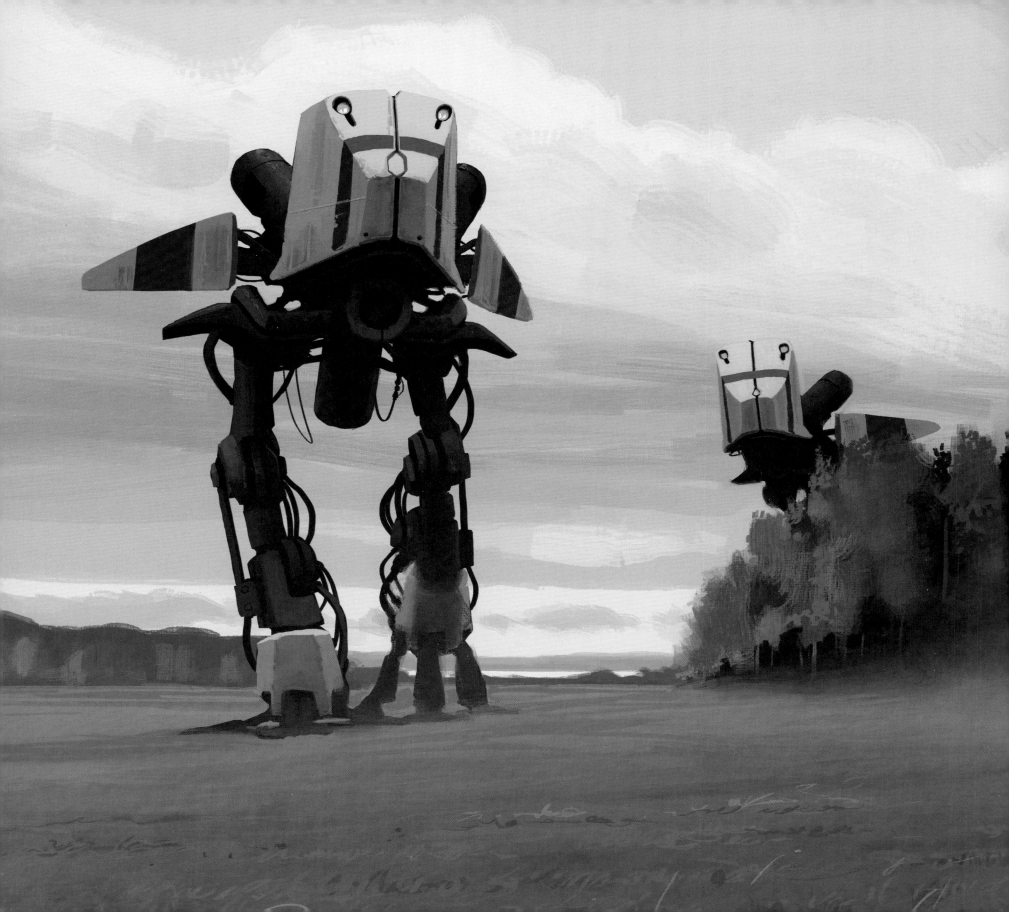

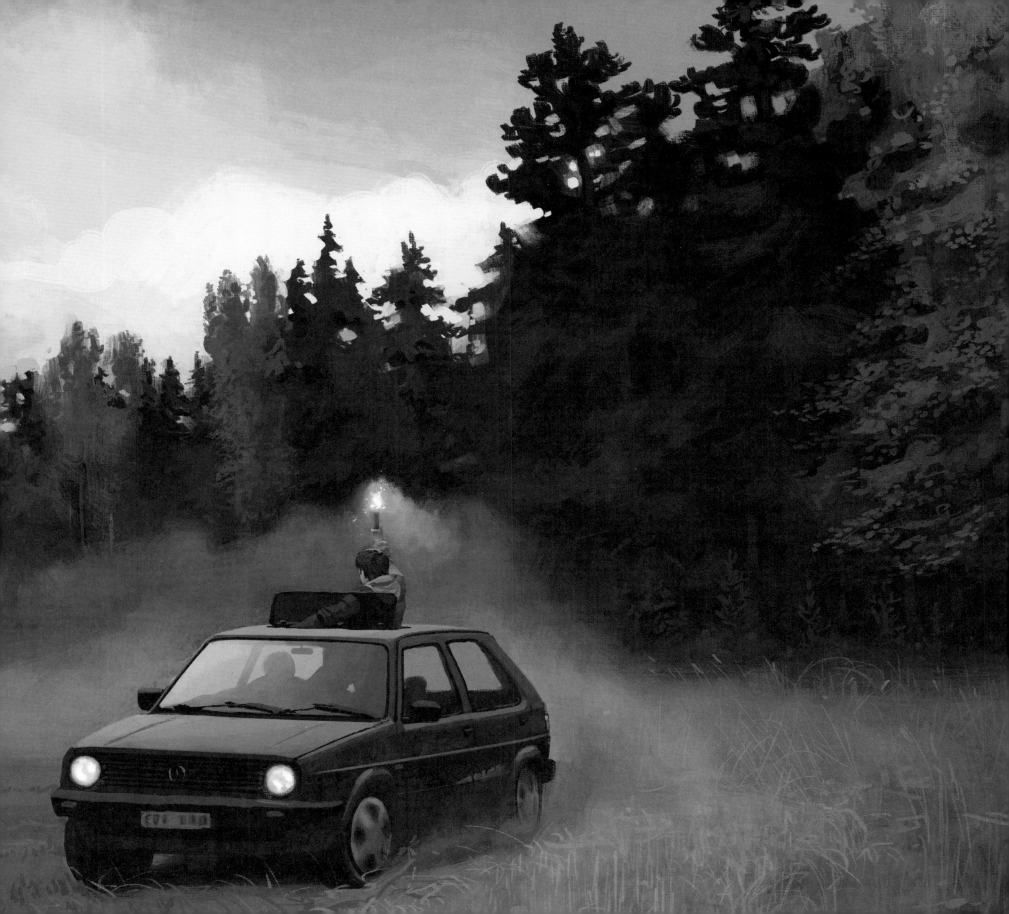

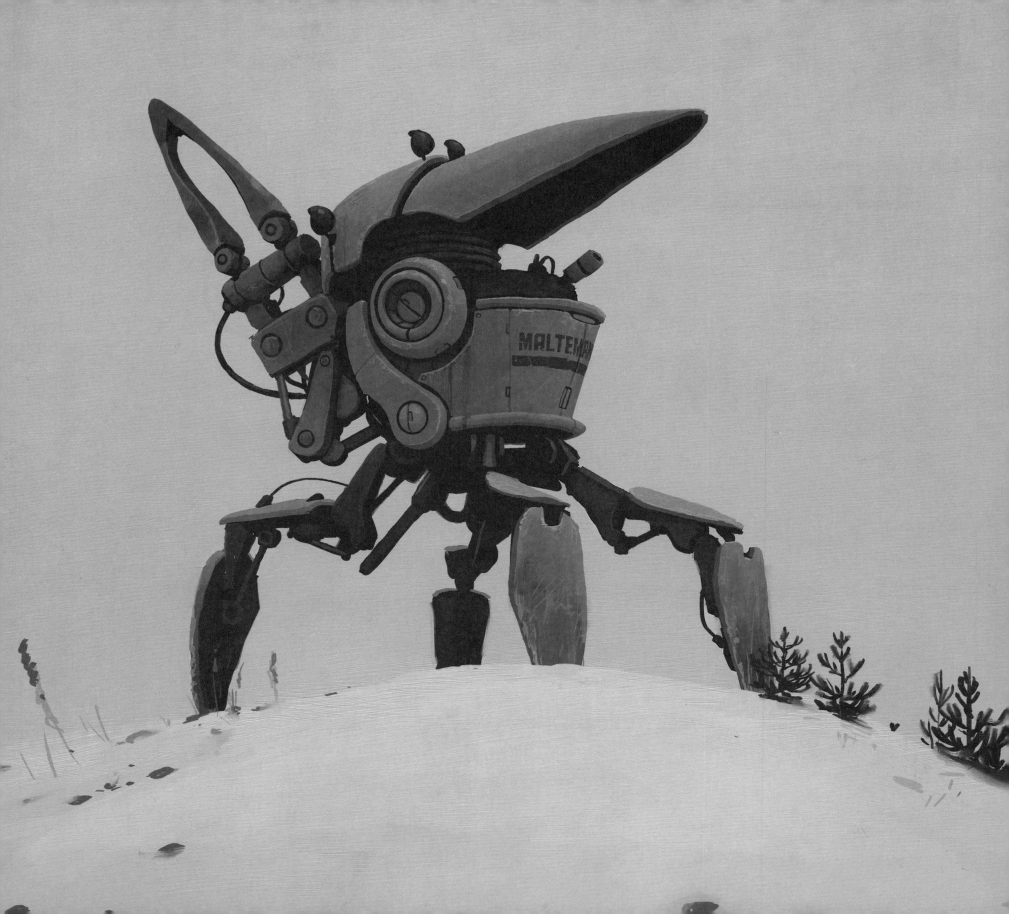

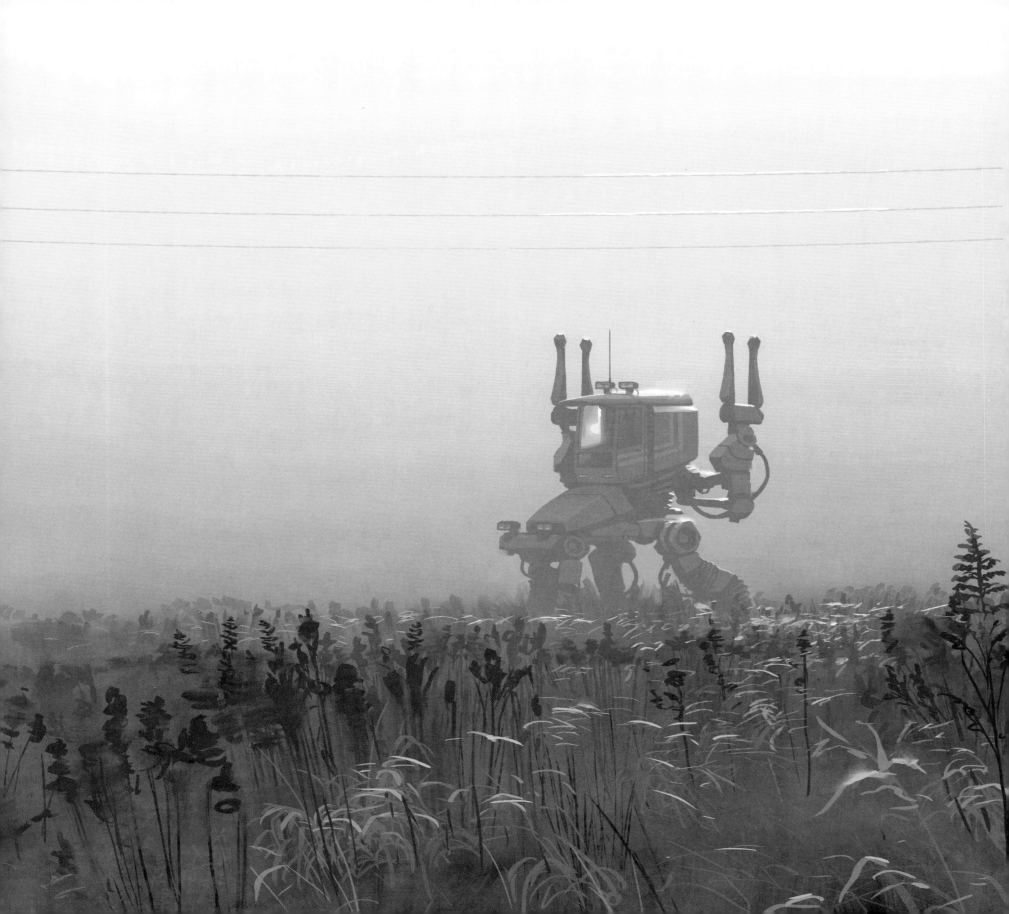

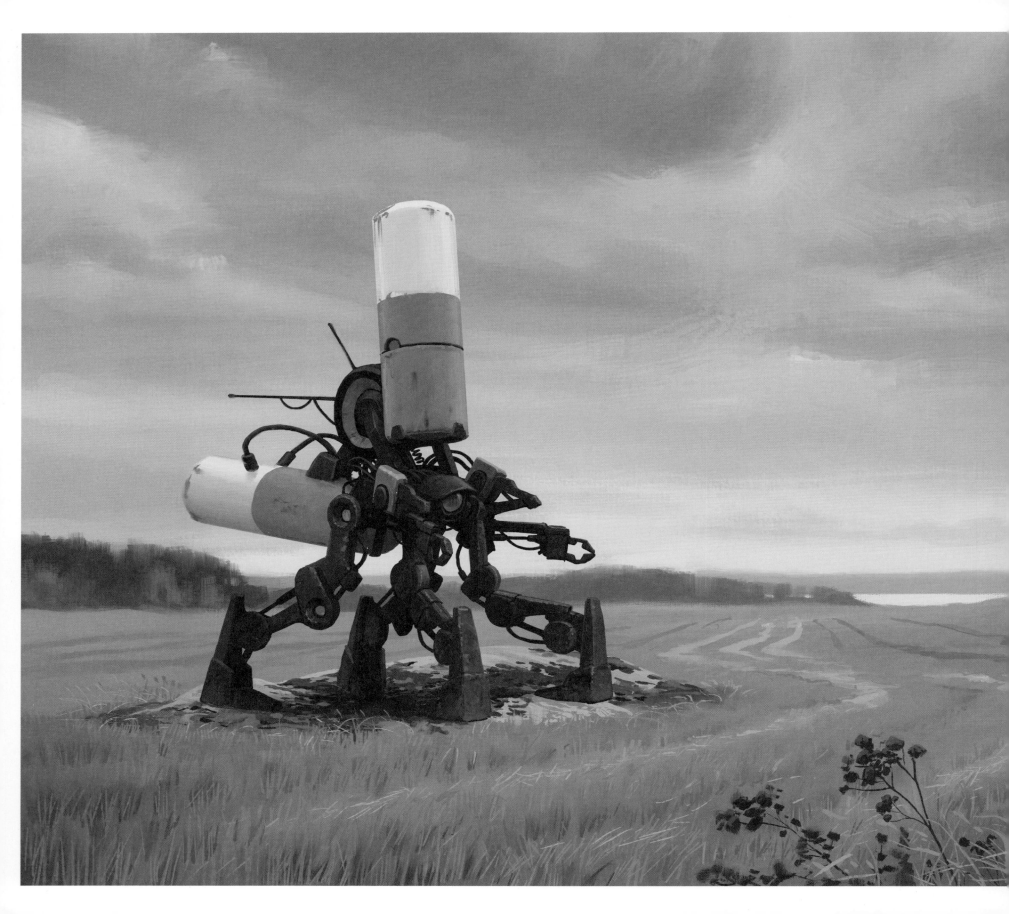

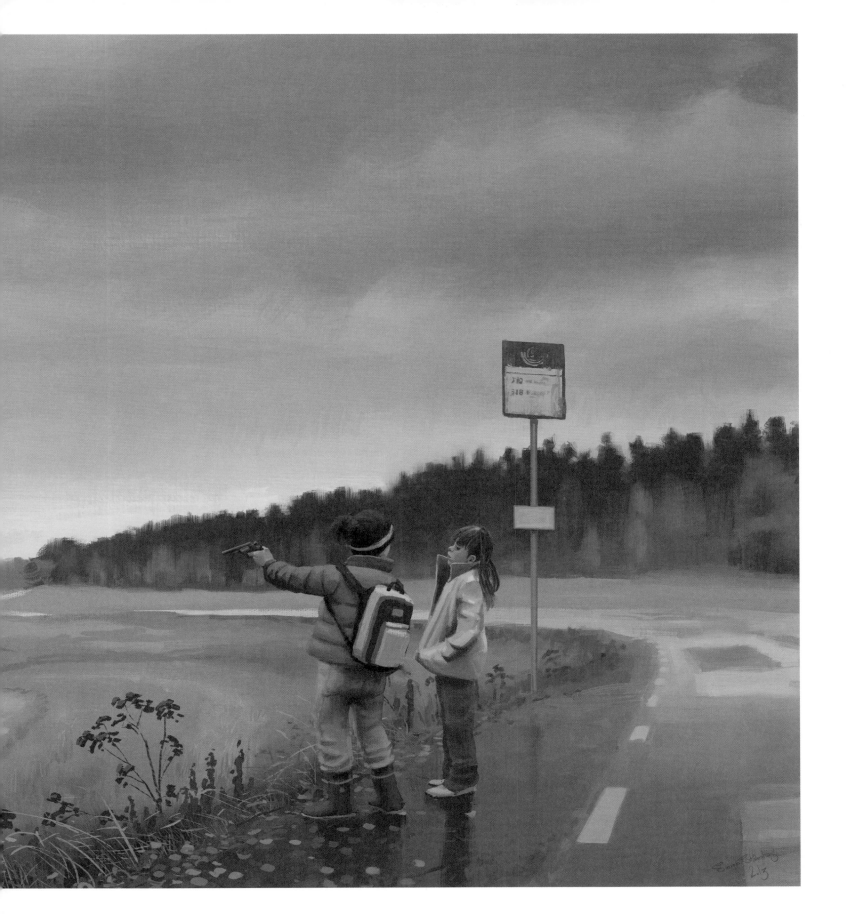

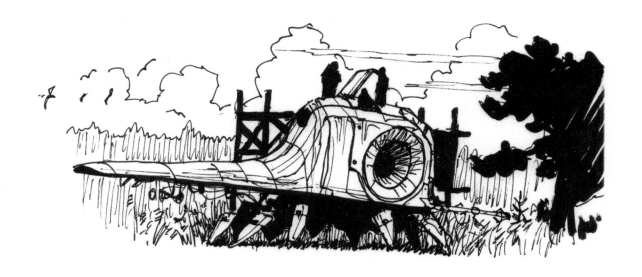

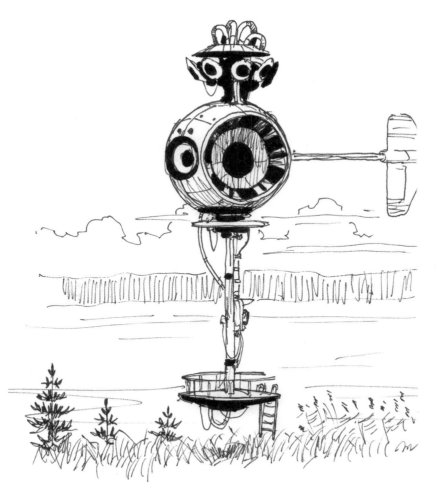

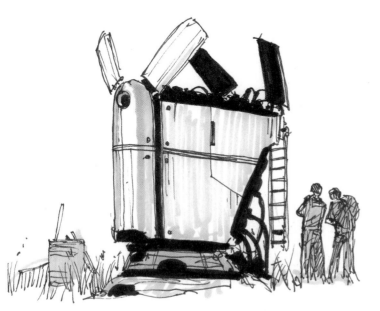

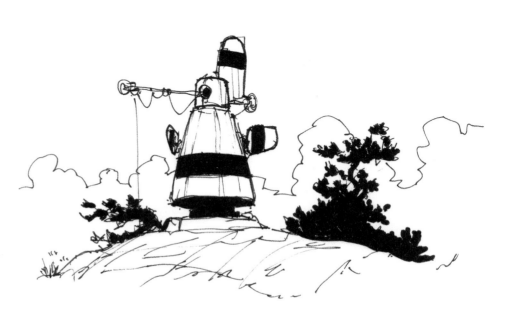

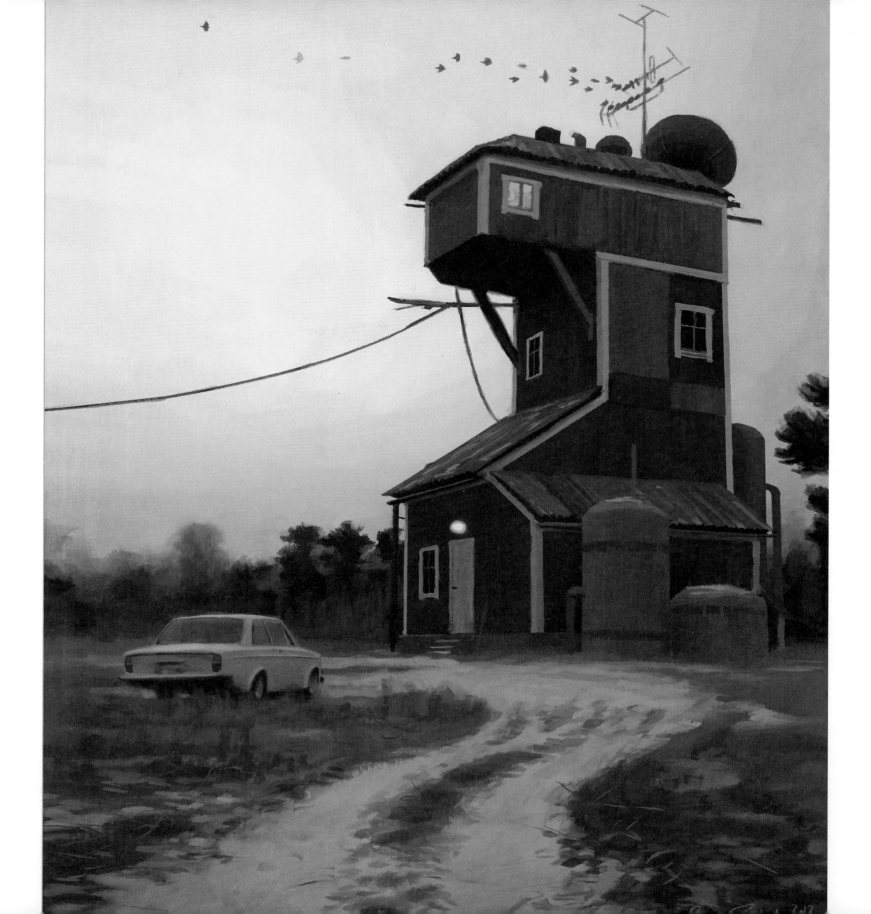

THE TOWER HOUSE

It truly was an enigmatic house. My father used to say it was just a regular house that a giant had lifted and flipped over on its side. Tons of old things towered along the walls, almost all of them things that had no place in a home. A big, shaggy German Shepherd strolled along the paths among all that junk, and somewhere in the middle of the clutter, always busy disassembling something, was the dog's master: my uncle, Alf. To say that it was messy would be wrong. There was an order here, and a feeling of recycling— sort of like a compost heap. Olof's house was messy in the worst sense of the word. It smelled of stale urine, and you just wanted to go home. The rooms in the Tower House smelled of oil, coffee, and dog, and somewhere a radio was always playing. I loved playing with the dog, even though my fingers became greasy and covered in hair.

In the basement there was a room connected to the extensive tunnel systems of the Loop. It was furnished with an old green couch, a coffee table, a couple of steel cabinets, and a locked steel cage. Inside the cage were hard hats, coveralls, and a board hung with keys. The far wall was dominated by a huge locked steel door marked with a big eight. Next to the door was a red telephone with a single button. The room was lit by a vending machine in one corner, filled with pastries and soda cans. If you were lucky Alf would conjure some coins from thin air, and you were allowed to feed them to the machine.

I often stood there, quiet and happy with a half-eaten pastry in one hand, my ear pressed to the steel door.

A lot of buildings out on Mälaröarna had a connection chamber in the basement. Usually they were found in houses built when the Loop was constructed. They were filled with coveralls, protective gear, first aid kits, and a direct line to emergency services.

JENS AND HÅKAN SWITCH BODIES

I can't help smiling when I think about the twins, Jens and Håkan. They had moved in from Skåne and were almost identical physically but behaved very differently, for those that bothered getting to know them. Håkan was a real menace who always ended up in trouble and Jens was a daydreamer, slouching along with his shoelaces untied. That was how their characteristics were divided when they came to our school in the third grade. They told us such a funny story.

Håkan claimed they had found a giant steel pod at a rest stop on the way from Skåne to Stockholm, when he went down to pee below the freeway. The pod had a hatch that was wide open, so he entered. In the same moment that he set foot inside the pod he was back in the family car again.

He sat in the back seat, in shock. His mother wondered why Håkan was taking such a long time, he was only going for a pee. Håkan didn't understand anything. How had he returned to the car so quickly? "Mom, I'm right here," he mumbled. Now he saw that Jens was gone. Håkan's mother turned around and stared at him angrily. Then she looked down at his clothes—even their parents were sometimes unable to keep the twins apart, and not only when it came to their names—and said, "Stop messing around, Jens." Håkan looked at his own reflection in the rear-view mirror and his breath caught in his throat. He had Jens' face and clothes! He ran out of the car and down to the pod again.

He found his confused and frightened brother in the pod. Amazing! Jens looked exactly like Håkan; they had simply switched bodies. Håkan led his brother back up to the rest stop and explained how things were now: Håkan was Jens, and Jens was Håkan.

According to Håkan, their parents never noticed.

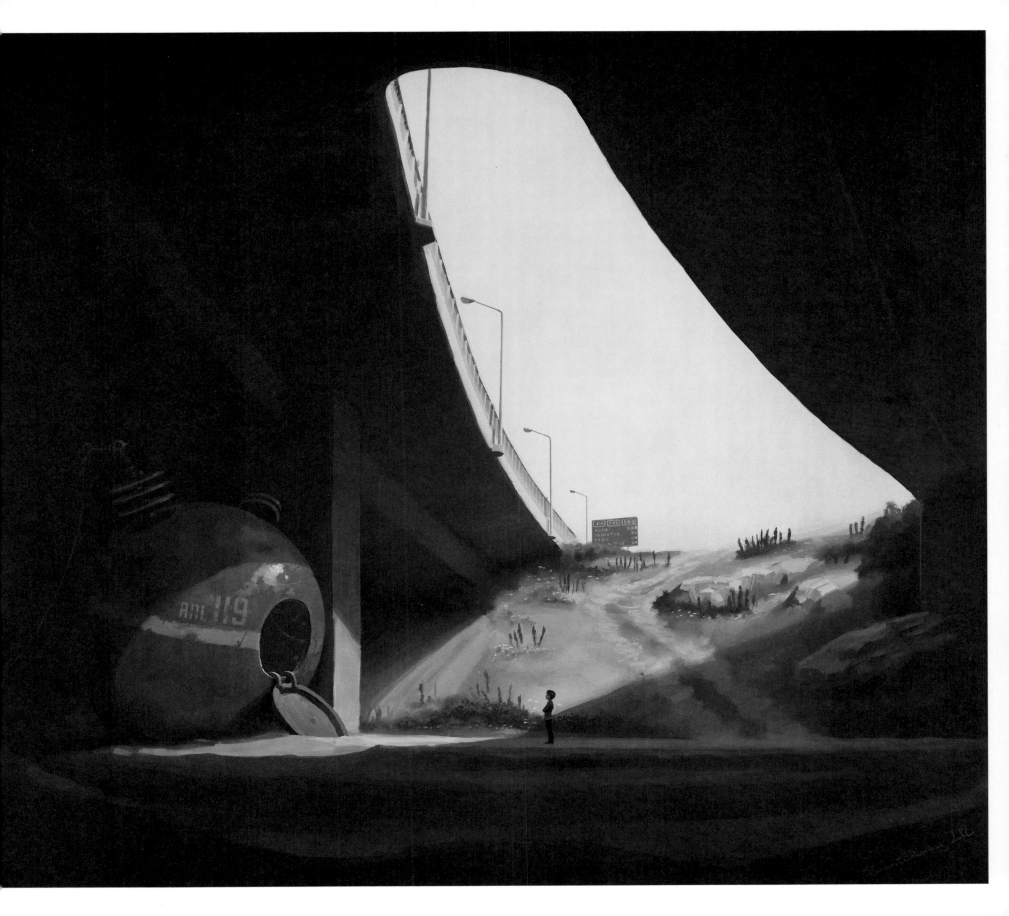

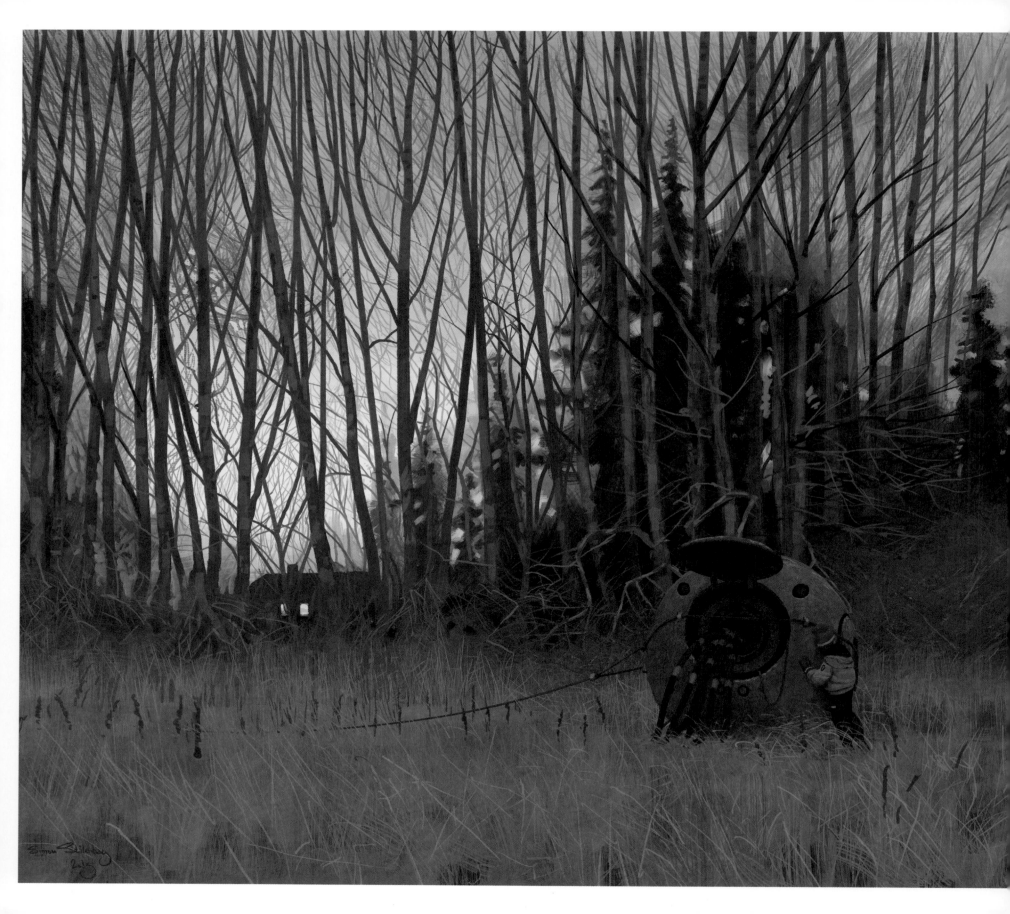

POSTCARDS FROM AMERICA

A project as big as the Loop could never have been realized without international collaboration. Even if Swedes would have liked to see it as a Swedish project through and through, it was clear that a lot of the technology and expertise behind the facility was developed in other countries, primarily in the USA. American experience and technology from similar projects in the Nevada desert turned out to be invaluable in the construction of the Loop. Some even say that the whole project was only possible because of an American desire to have a technological presence in the Baltic Sea area. There was much speculation about what part the Loop played in the Cold War, and some questions may never be answered. On the other hand, almost all the children on Mälaröarna remember the echo spheres that lay scattered across the landscape. Seemingly disconnected and powerless, sometimes they could emit noise; sometimes they were warm to the touch; and sometimes something flickered inside, like flashes of lightning. Some claimed they had seen the echo spheres leak water for days, in volumes that they couldn't possibly contain. Many remember the inscription on the side that said:

Manufactured by
ROGOSIN LOCKE INDUSTRIES, BETHESDA, MARYLAND

According to Magnus in 6B there was surely a connection between the echo spheres and the USA. Literally. The one thing he was admired for was his accurate penalty shots when we played soccer during recess, so his stories may have been designed to get some attention during the winter months, when the soccer field lay frozen and empty. What follows is what he told us.

Magnus spent his winters frenetically practicing penalty shots in the field behind his house. There was an old echo sphere there. He opened its hatch and used it as a target. In February, he was in good shape and made almost every shot. The sphere rang like a gong with every hit. To get a bigger challenge he walked off and placed the ball a good 40 meters from the echo sphere. He made a perfect kick that sent the ball like a target-seeking missile straight through the hatch. But—instead of the satisfying ring—there was total silence.

Magnus climbed into the sphere to retrieve his ball and somewhere there his fairly pedestrian, boastful story morphed into a long, incoherent hero's tale about how he passed through a portal in the echo sphere to a small town in the American desert. He had roamed there for days until he was caught by the sheriff and was imprisoned in a factory, where they had tried to grind him into tissue to be used in the construction of cyborgs. Luckily, he had managed to escape with the help of a four-legged war machine called Rosanna, and he then freed the town from a corrupt mayor, breaking the hearts of every single cheerleader in the town in the process.

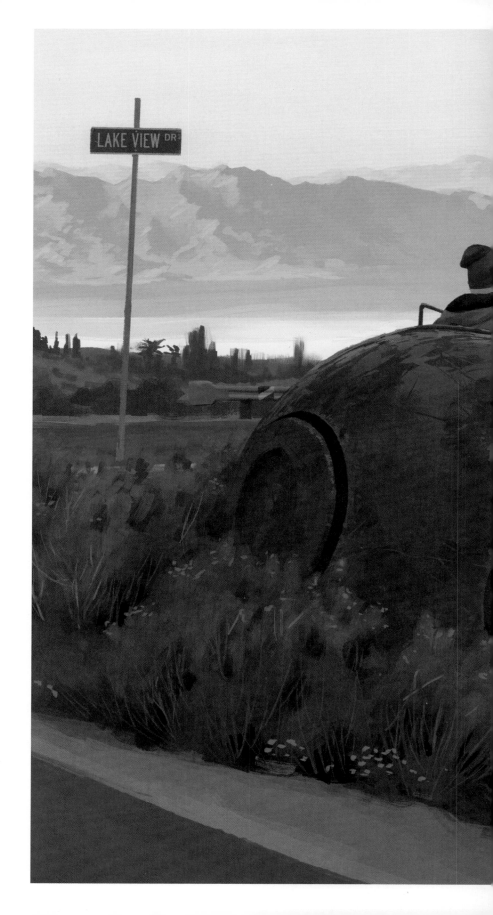

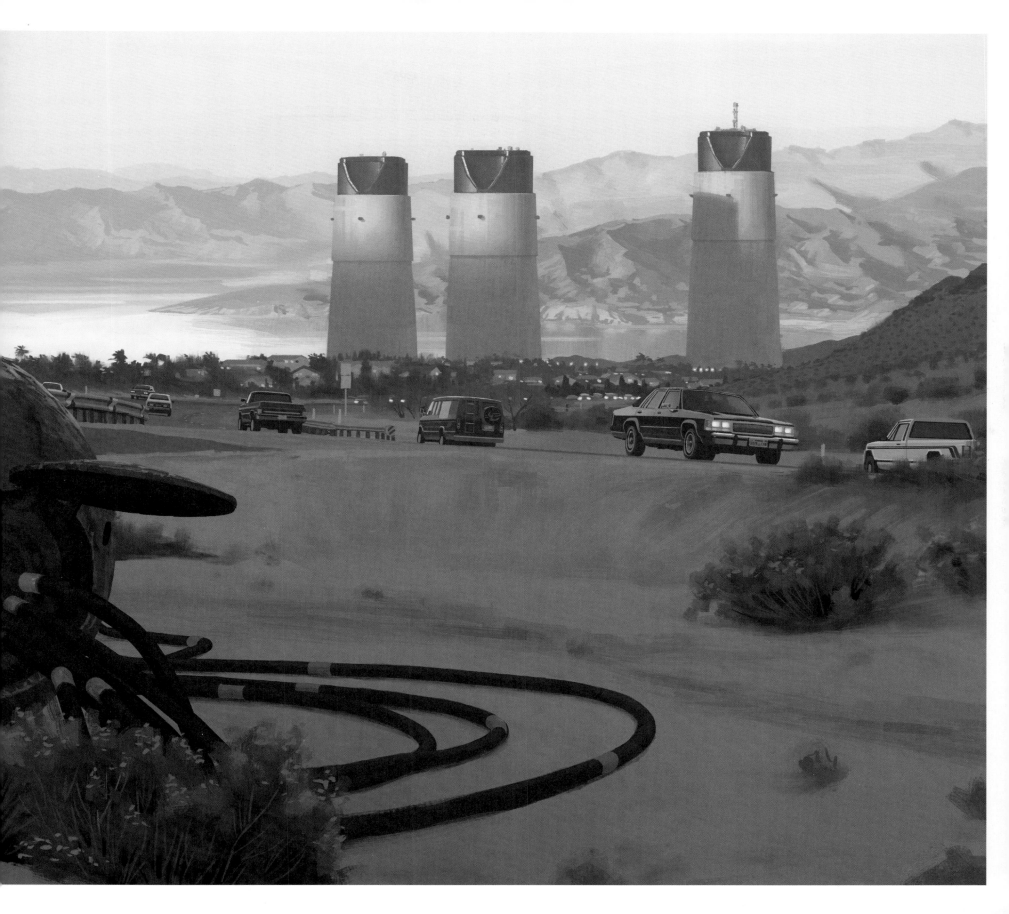

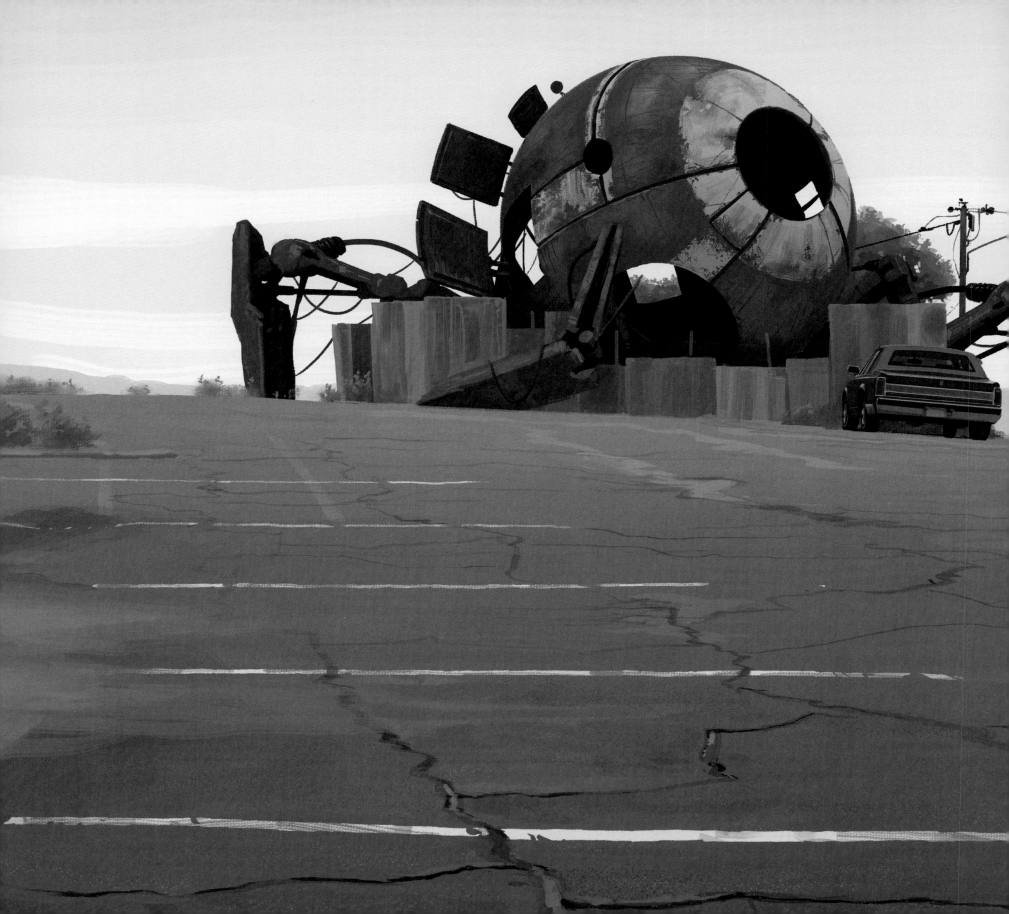

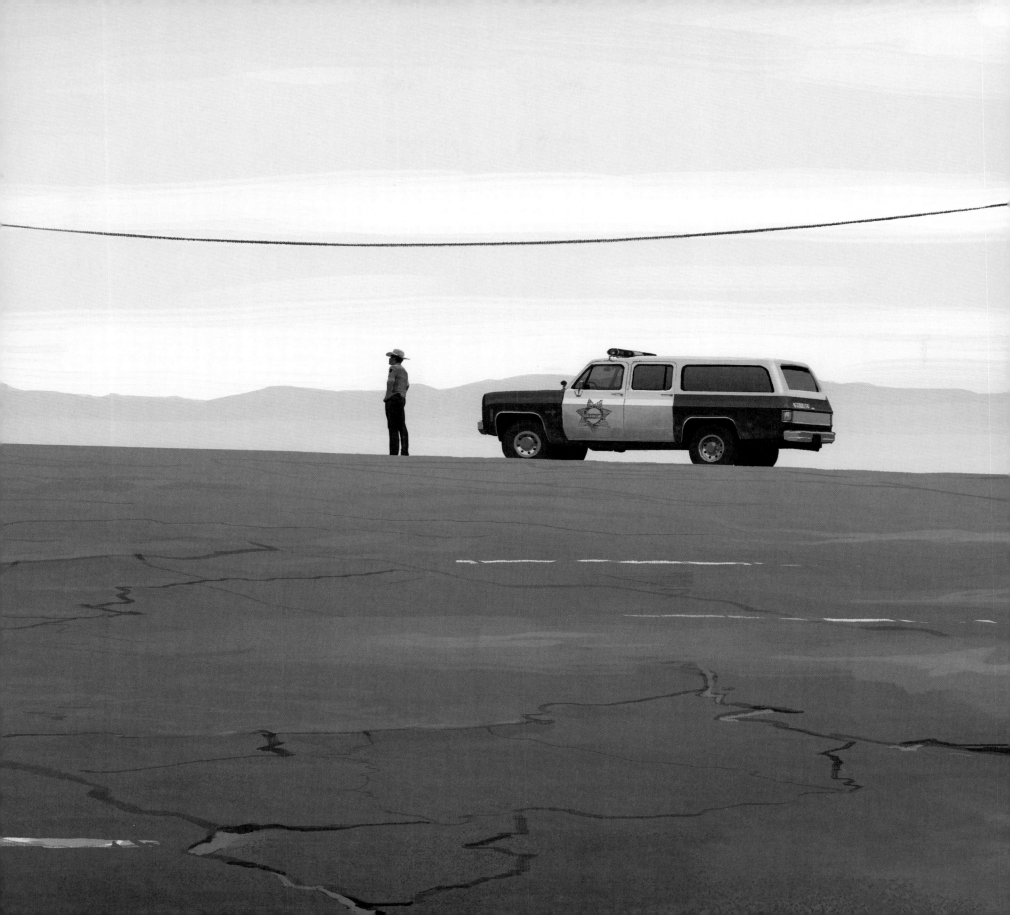

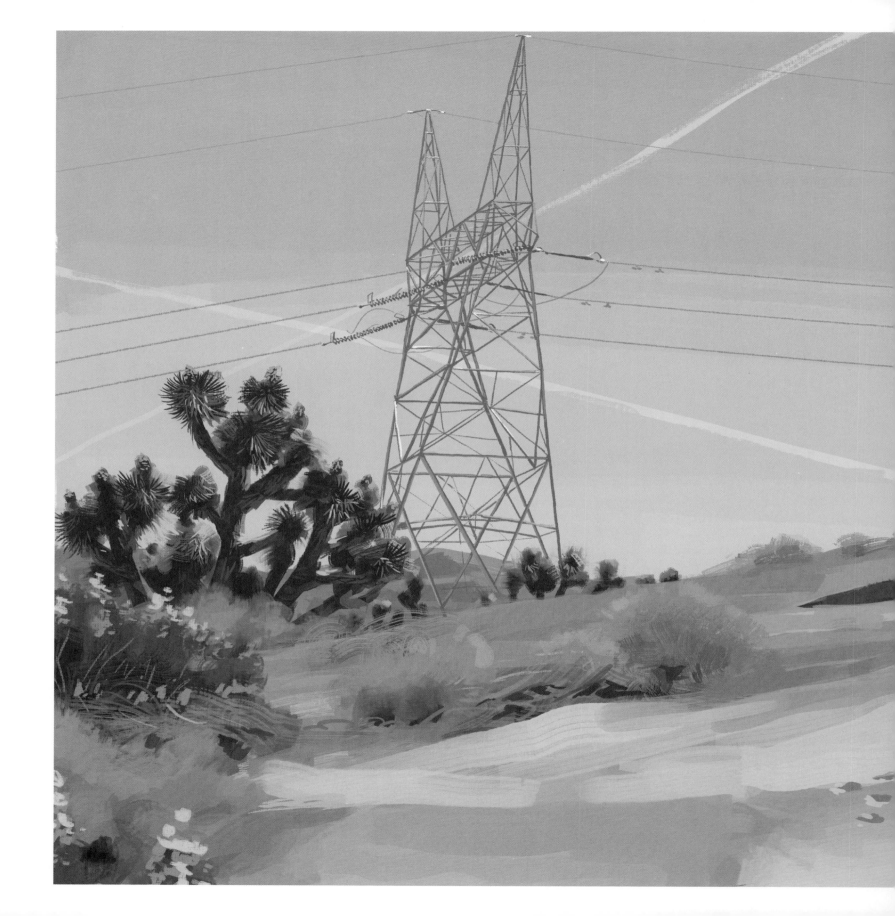

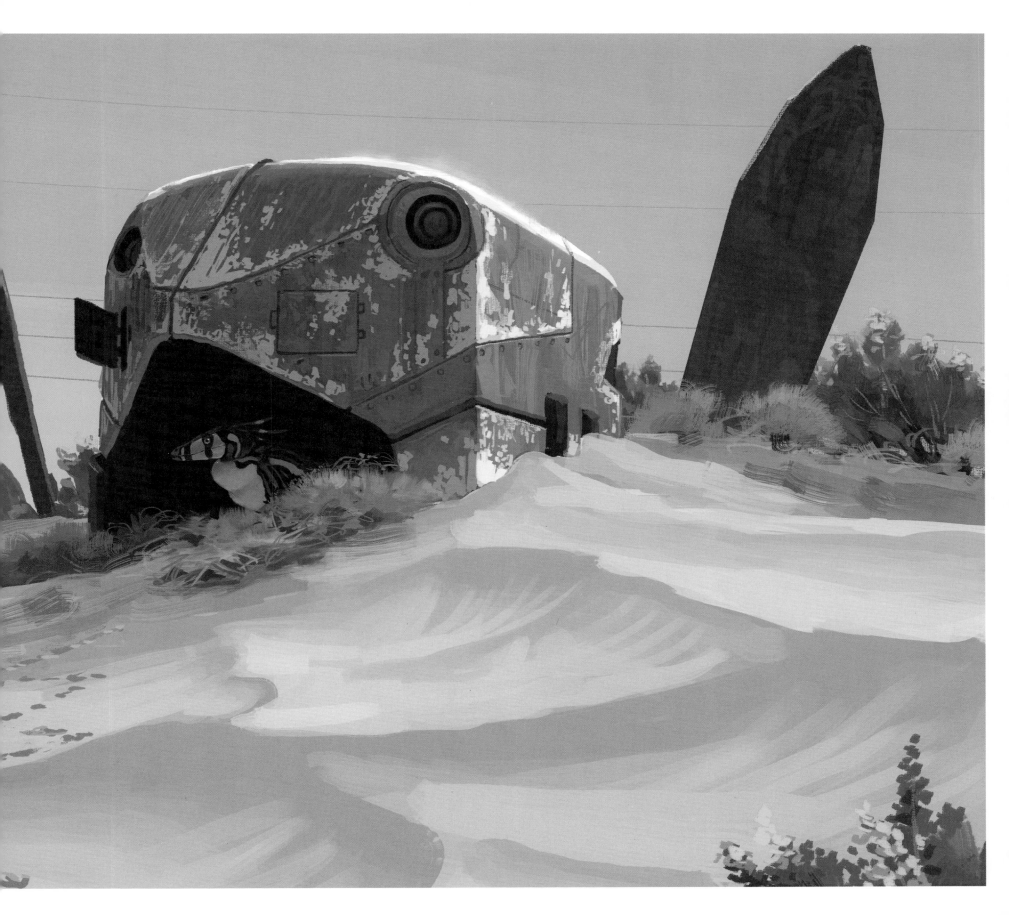

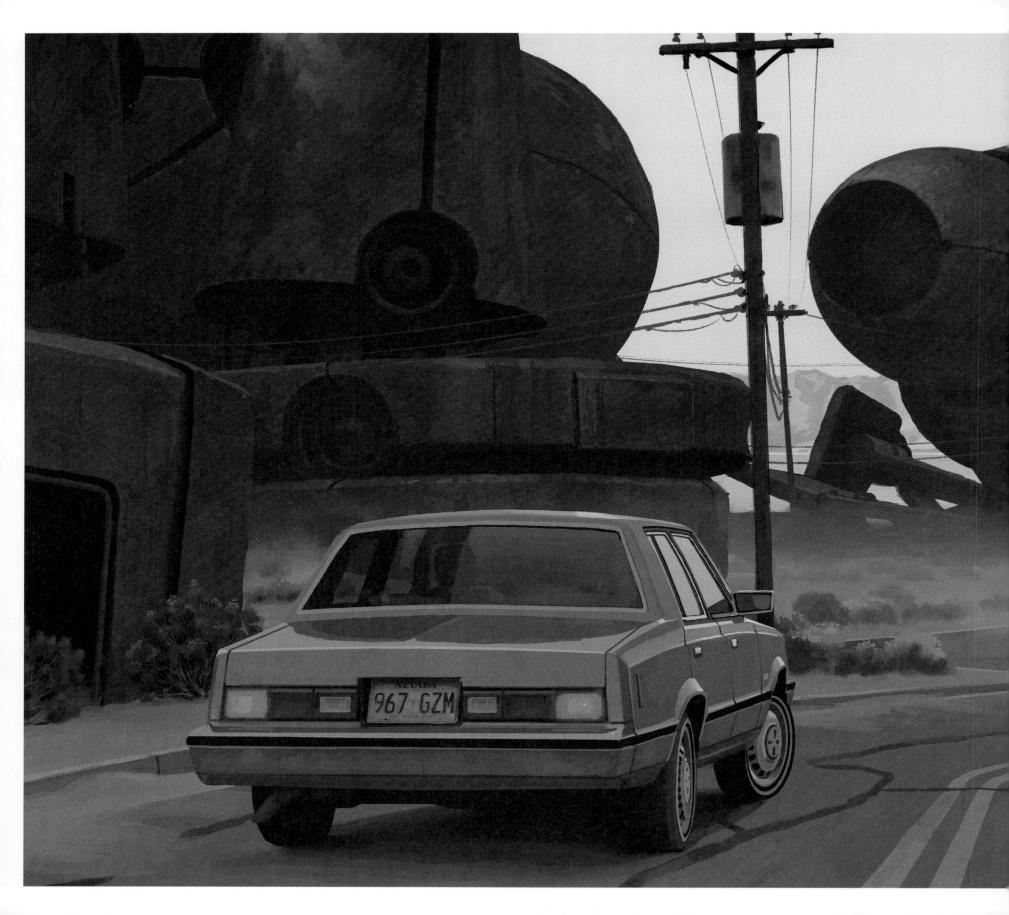

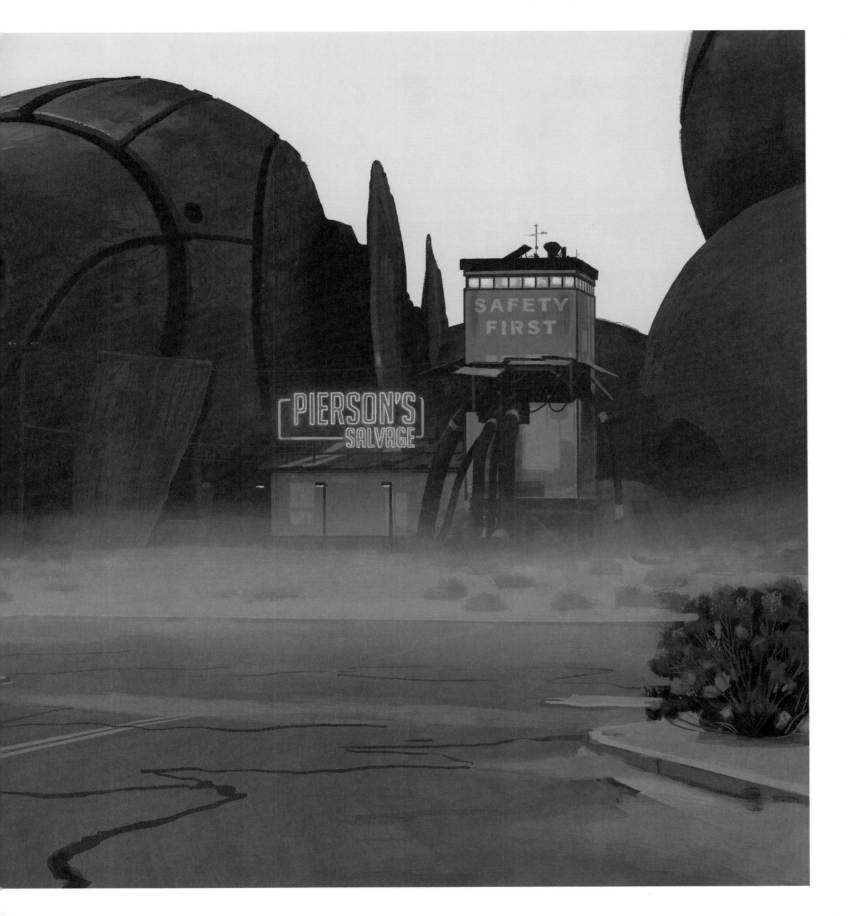

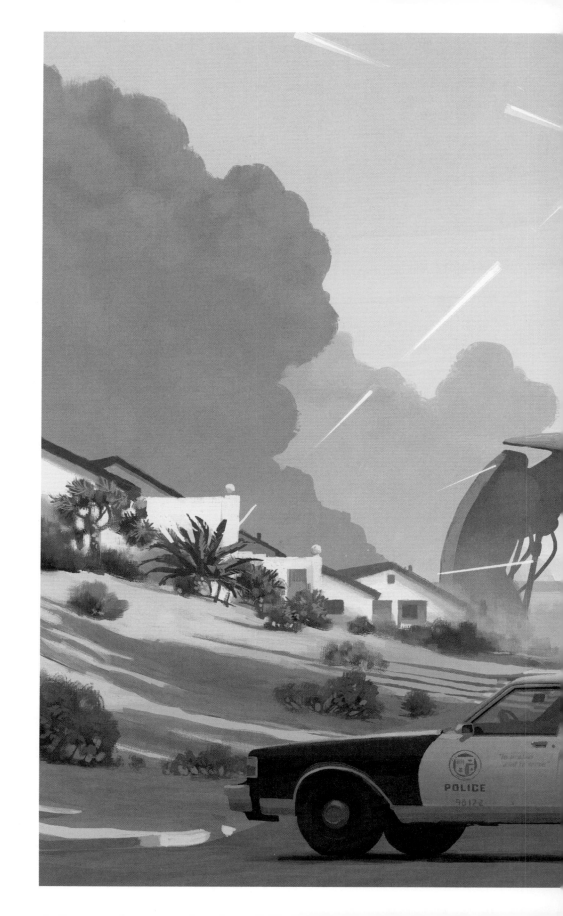

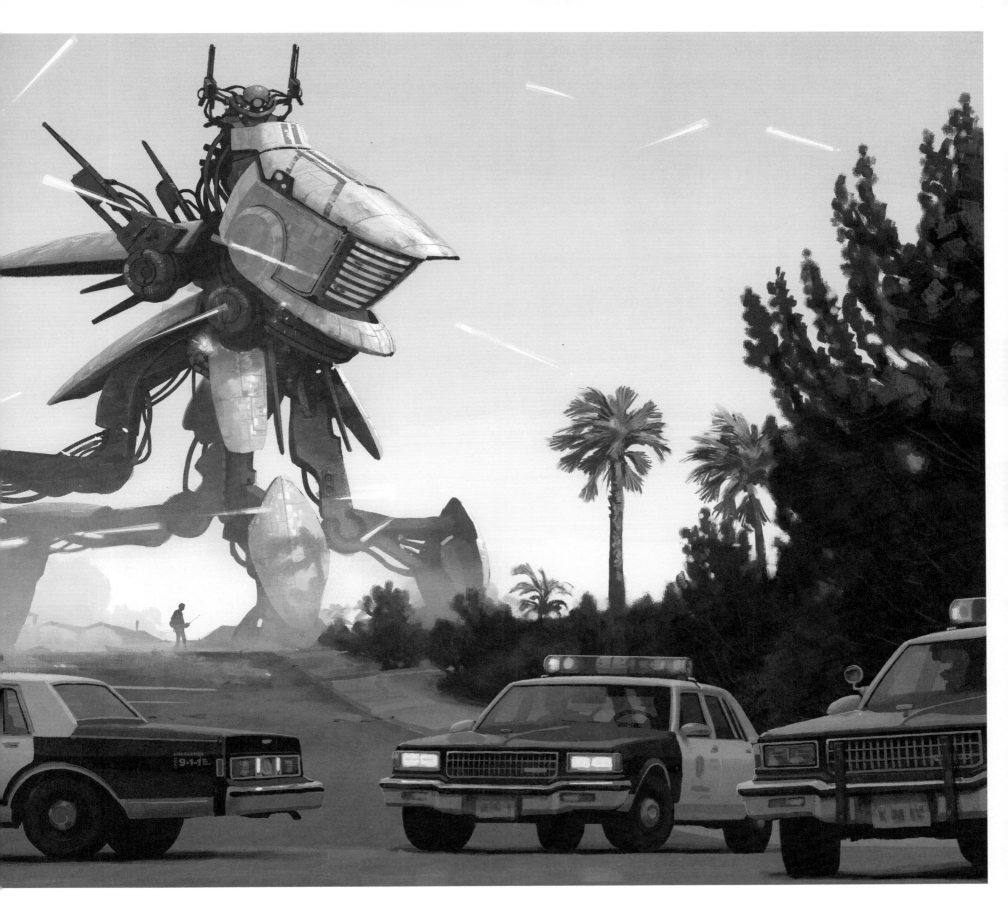

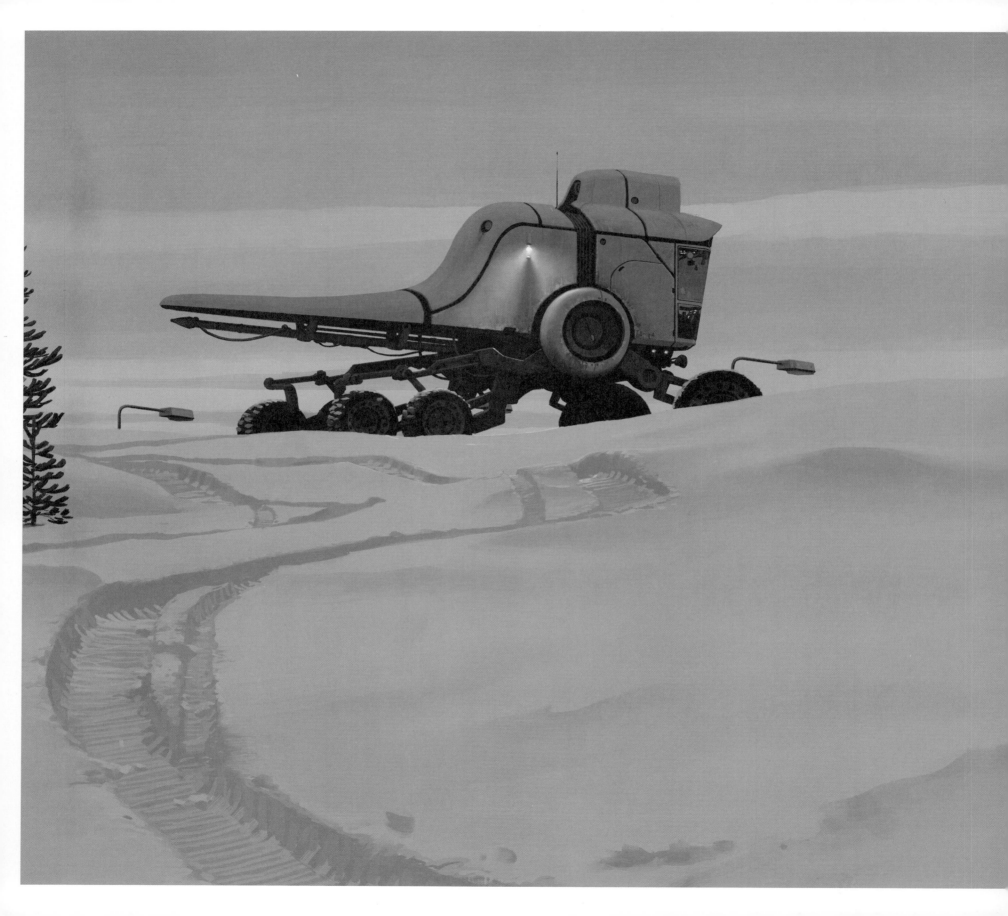

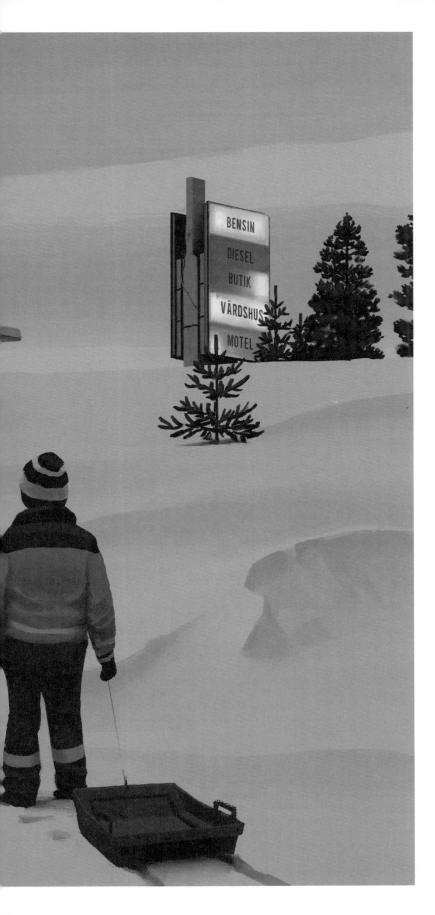

THE SPECTRE FROM SIBERIA

During the seemingly endless winters in the '80s, Riksenergi invested in a number of all-terrain vehicles, the eight Vectra Lynx among them. The Lynx spurred the imagination, because it was based on a prototype of the Soviet Gurevich that had been used as a recon vehicle during the Baikal Wars in the '70s. The Vectra version was neither armed nor armored, but you could still discern the vehicle's military past when you saw how easily and aggressively it traversed snowy cutovers and hillocks. My fascination with everything to do with Riksenergi began when I was just nine, and I used to walk around with a small camera to take pictures of all things related to Riksenergi.

The Vectra Lynx was one of my favorites and the only wheeled vehicle on my top ten list. If I saw suspicious tracks in the snow, I would follow them for hours. I even had a model kit of the Soviet combat version that I had assembled and painstakingly painted, with every single detail in place and to spec. On my bedroom wall I had a poster with the legend "Gu LRV 29 – THE SIBERIAN SPECTRE" that showed the Lynx in a dramatic combat scene in a flurry of snow, the ground covered with Chinese war robots that had been blasted to pieces.

THE SÄTUNA SPIDERS

The Sätuna Spiders were a form of security vehicles meant for repairs in hazardous environments, like the Gravitron chamber in the Loop—a gigantic hall deep beneath the Loop's center that housed the magnificent Gravitron, the heart of the facility. The floor in the Gravitron chamber was extremely hot and had a very strange topography: it was sectioned off in small quadrants, where every quadrant had a different height and gradient, making the floor almost inaccessible.

The spider vehicles ended up in Sätuna in 1978, when Göran Friske had the idea to buy used equipment from Riksenergi and convert it for agricultural purposes. He bought thirteen used spider vehicles with the intention of developing a new kind of farming machine that could negotiate any terrain. Unfortunately, the Spiders turned out to be too slow and their operational costs were too high, so the prototypes simply stood in an old field behind Friske's farm.

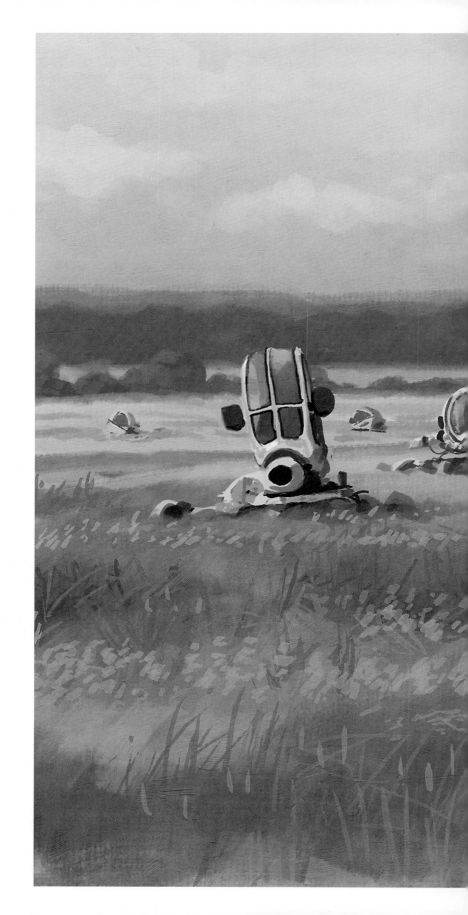

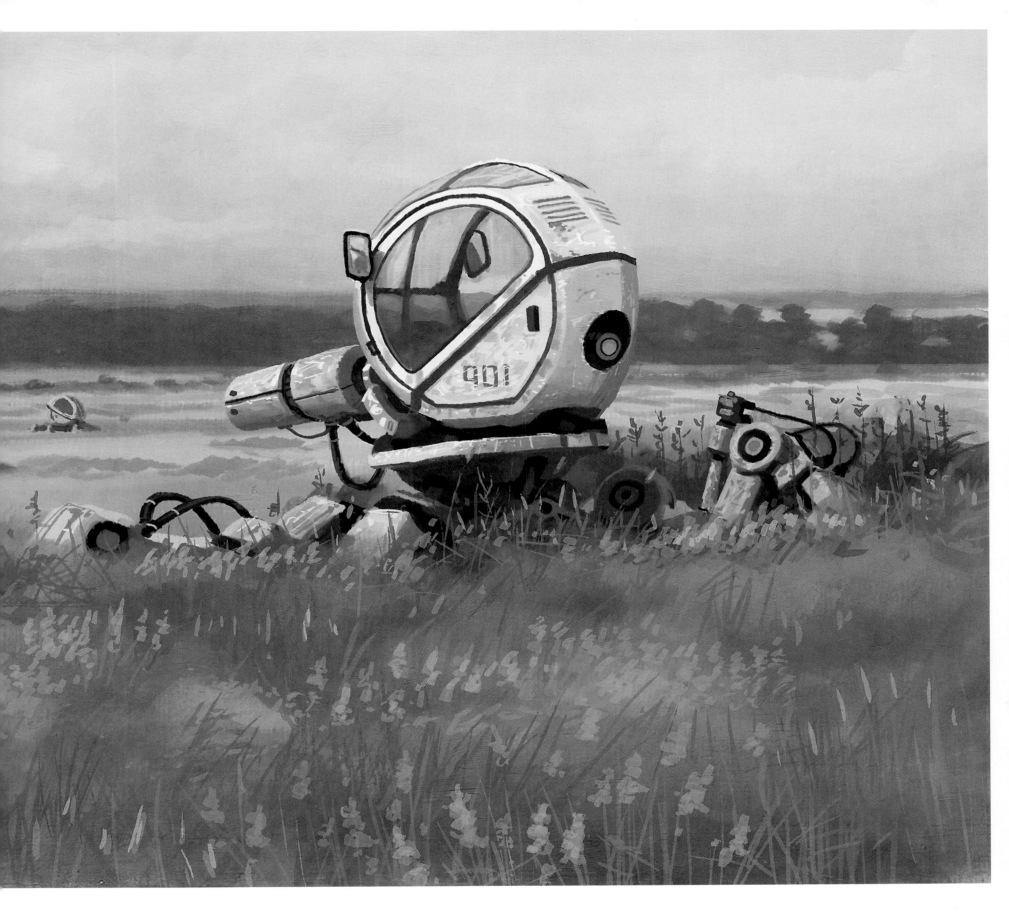

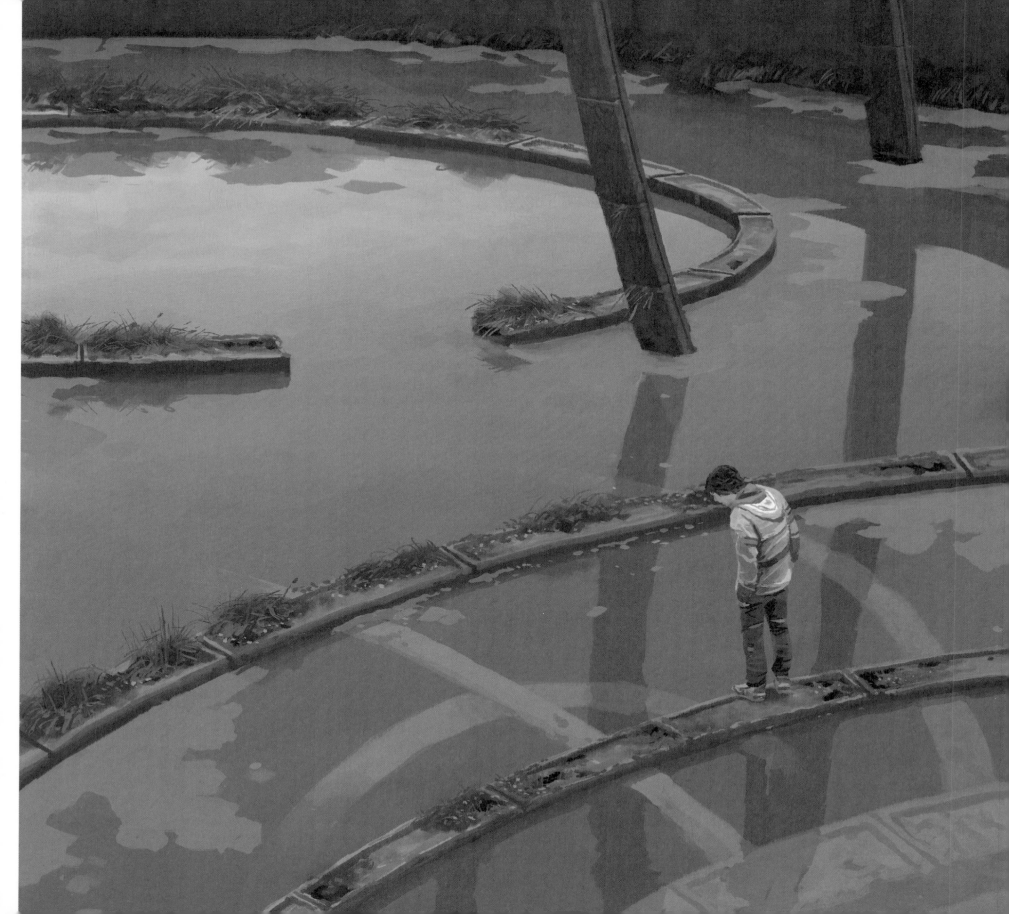

THE DÄVEN MONSTER

The factory on Dävensö had been almost completely reclaimed by nature by the late '80s. At the back of the factory complex, in a large concrete building, was a big hall where the roof had caved in a long time ago. Once upon a time the final assembly of huge magnetrine discs had taken place here, beneath the waters of a large reservoir. The ruins of that hall were a favorite spot for the local children to sneak into.

Large schools of tiny perch swam beneath the surface. Now and then you could also see a bigger fish.

Stories were told of something huge and horrible living down there in the water. Maybe a water spider, or some amphibian, had nested in one of the reservoir's many dark crevices and given birth to something malformed, a lifeform changed by heavy metals and chemicals that had leaked into the water. Maybe it was something that had arrived from another dimension through a tear in space-time, caused by the experiments down in the Loop.

Maybe there was something down there in the reservoir, but the only thing that ever floated to the surface was the body of Ragnar Jönsson, a local thug. He used to stay in a trailer out on Dävensö and it was assumed that he had fallen into the water when he was drunk, and had drowned.

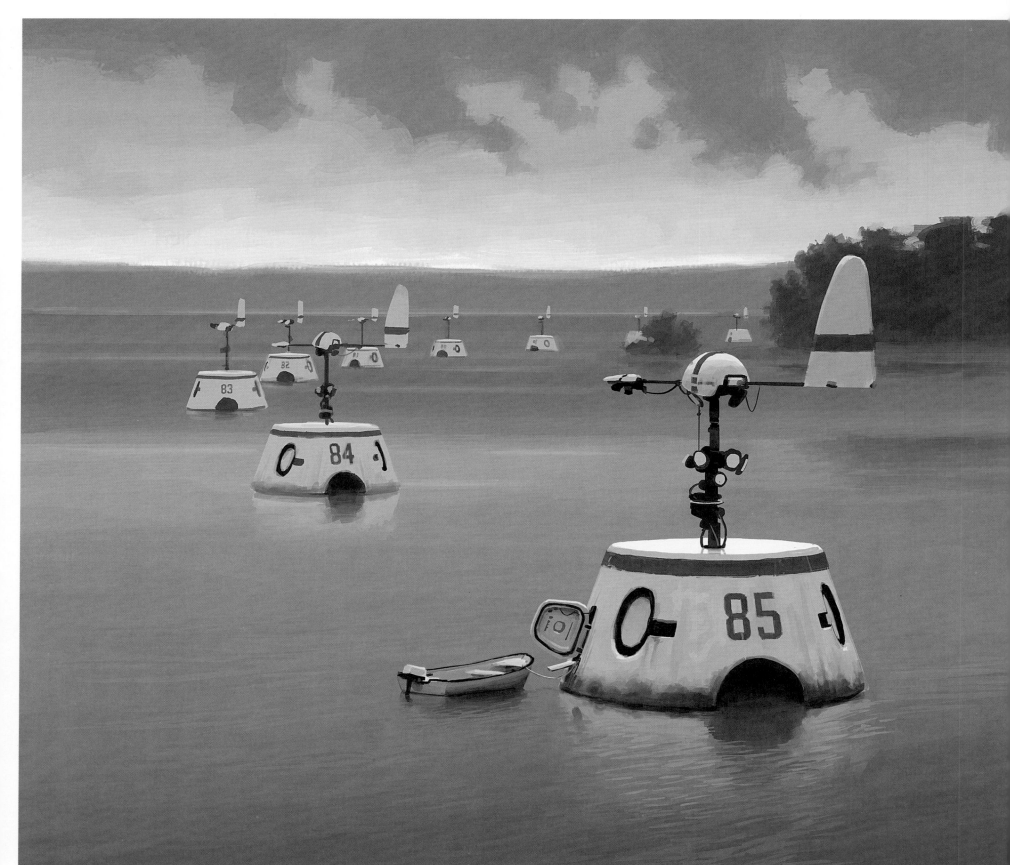

THE MOOMIN

Ninety vane turbines followed the shifting temperaments of the wind with silent, studious precision in the water outside Lagnö. Their round pressure hatches made them look like funny little old men that peeked up above the surface out there. They were commonly known as the Moomin, and they had a very important task to perform. The pumps on Lagnö needed minutely-detailed data to be able to adjust pressure and empty deuterium, in a steady flow without dangerous fluctuations, from the outer tunnels of the Loop. Just a minor interference could send shock waves through the structure of the entire Loop, even into the Gravitron chamber itself. The jagged alabaster floor would disperse any such shock waves of course, but the smallest deviation could send the pulse spheres of the Gravitron into an uncontrollable spin. The safety systems were rigorous and the risk of a meltdown seemed practically nonexistent, but the thing was that no one really understood the Gravitron. An anxiousness shone through in the thousands of pages of safety manuals, which pervaded all activities at the Loop.

When we swam down by the guest pier at the boat club in summer, we would dive down to the bottom wearing masks and explore all the old junk that had been deposited in the mud over the years. Shopping carts, old plastic bags, beer cans, fishing lures, and incomprehensible iron constructions stuck up from the mud down there. When you disappeared under the water's surface, the hubbub of summer days was cut off and you entered the silent netherworld of Mälaren. Distances were distorted and, down there in the green glow, the sound from a distant boat—not even visible on the surface—could be heard loud and close. I remember at the end of August, when the vacationers started to migrate back to the city and the guest pier was deserted, you could hear the distant breaths of the vane turbines rise and fall under the water, like monotonous whale songs in the chilly water.

THE SCRAPPERS

Thirty years of Loop operations had filled the Mälarö landscape with strange objects. A kilometer along Ettans Road, two brothers, who had a knack for all things mechanical, had slowly allowed their garden to be populated by scrap. Old front loaders, spine arches, field hats, solar turbines, whisper flares, and magnetrine discs threw shadows over the stunted apple trees.

The two brothers were skilled mechanics and made a living fixing people's cars, but there was always a sense of hidden tragedy in their house.

In the summer of 1992, Autoproffsen opened their first workshop on Svartsjölandet and the brothers were unable to compete with their prices. A year later they were out of work. They became more and more reclusive, and soon they erected a large warehouse in their backyard where they could work undisturbed. You could hear mechanical noises from within the warehouse well into the night.

One day, in the fall of 1993, the brothers were gone. Their property was cordoned off and strung with police tape. Some said the brothers had committed suicide; others claimed they had been preparing some act of madness. During fall break that year, Pontus and Mackan of 5B said they had entered the warehouse and found a gateway to another dimension, also wrapped in police tape.

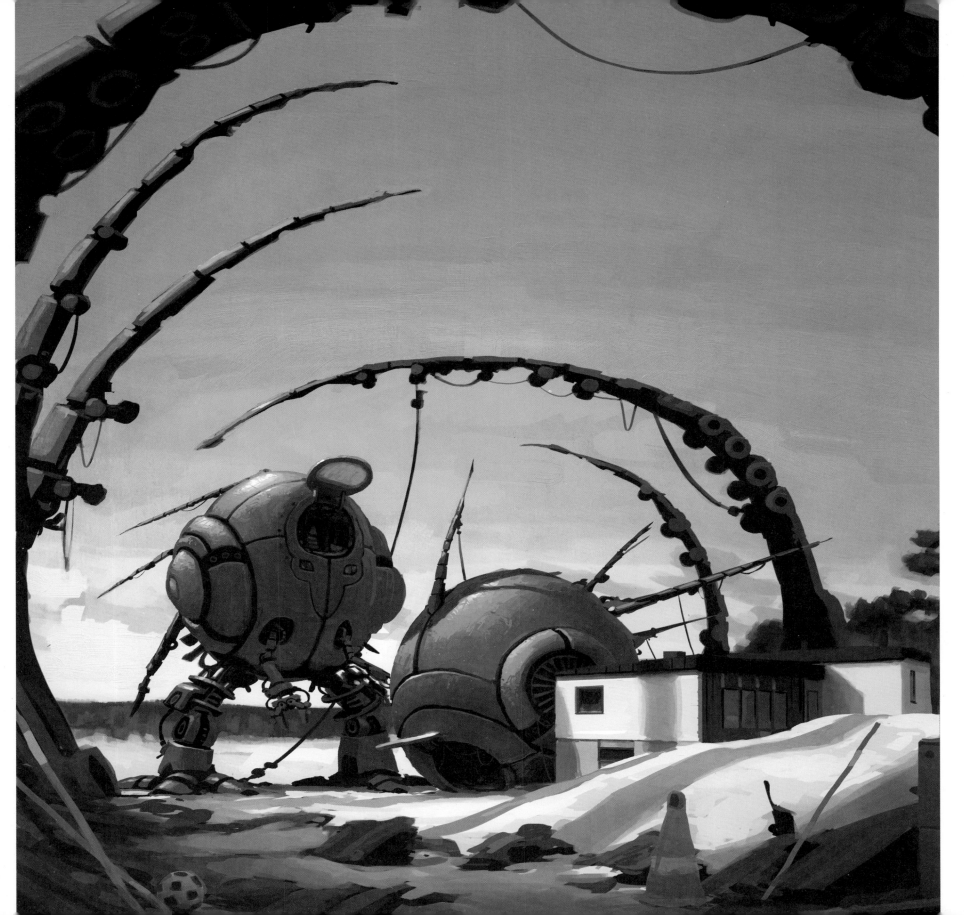

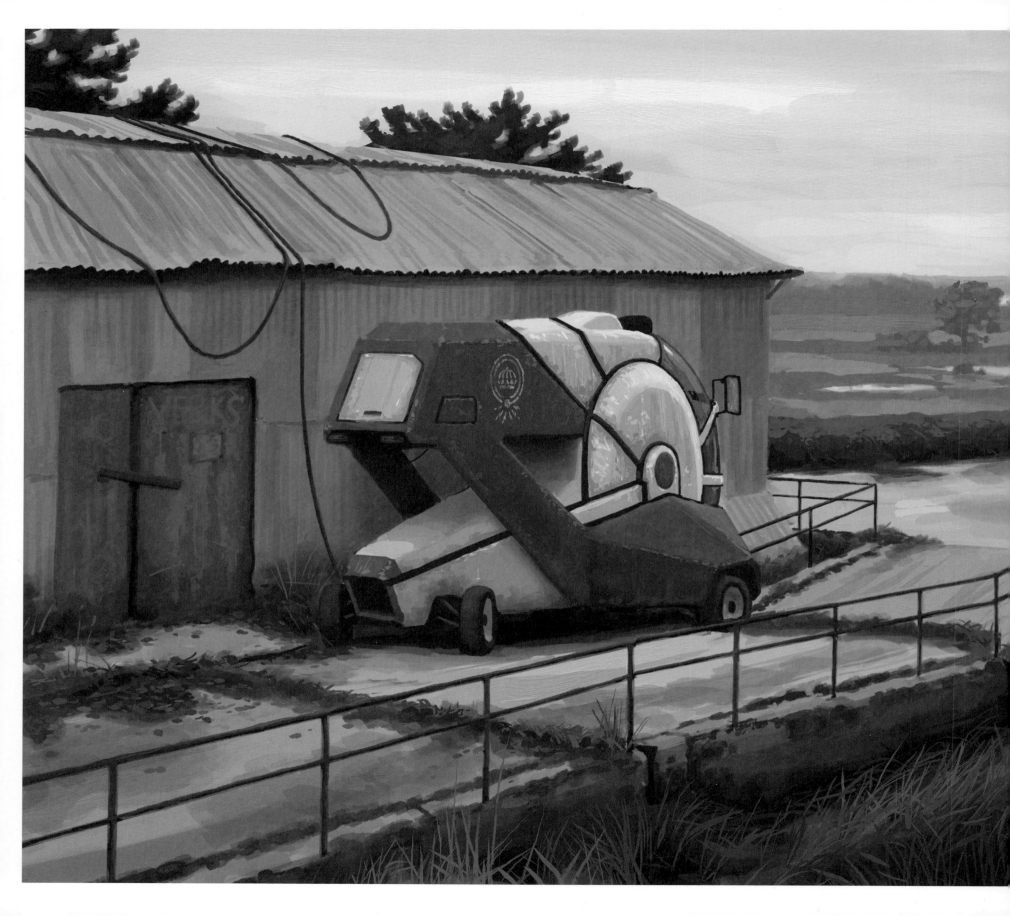

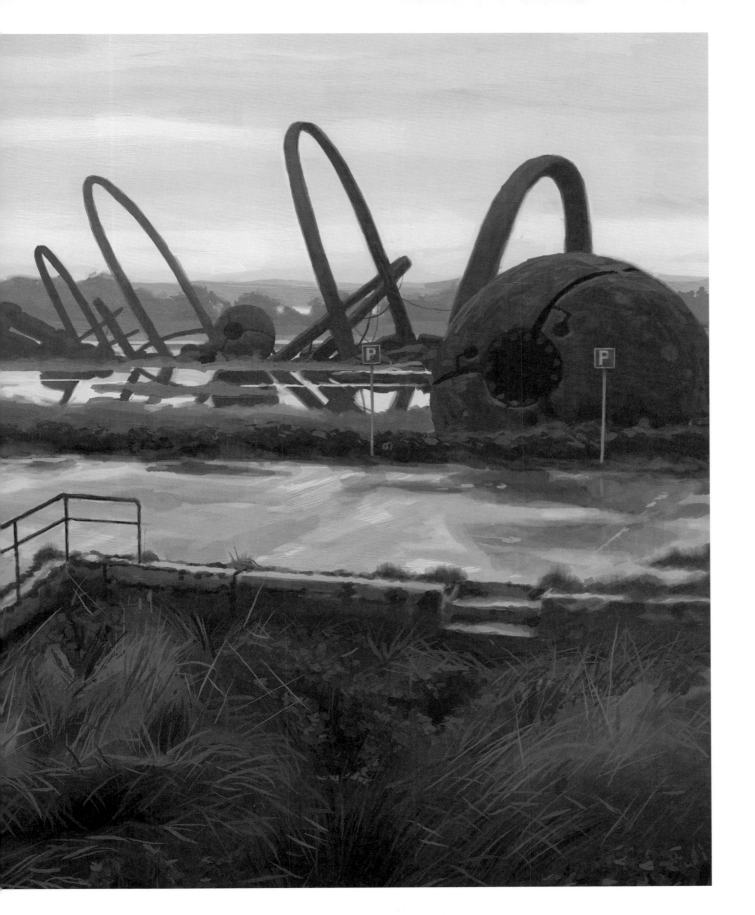

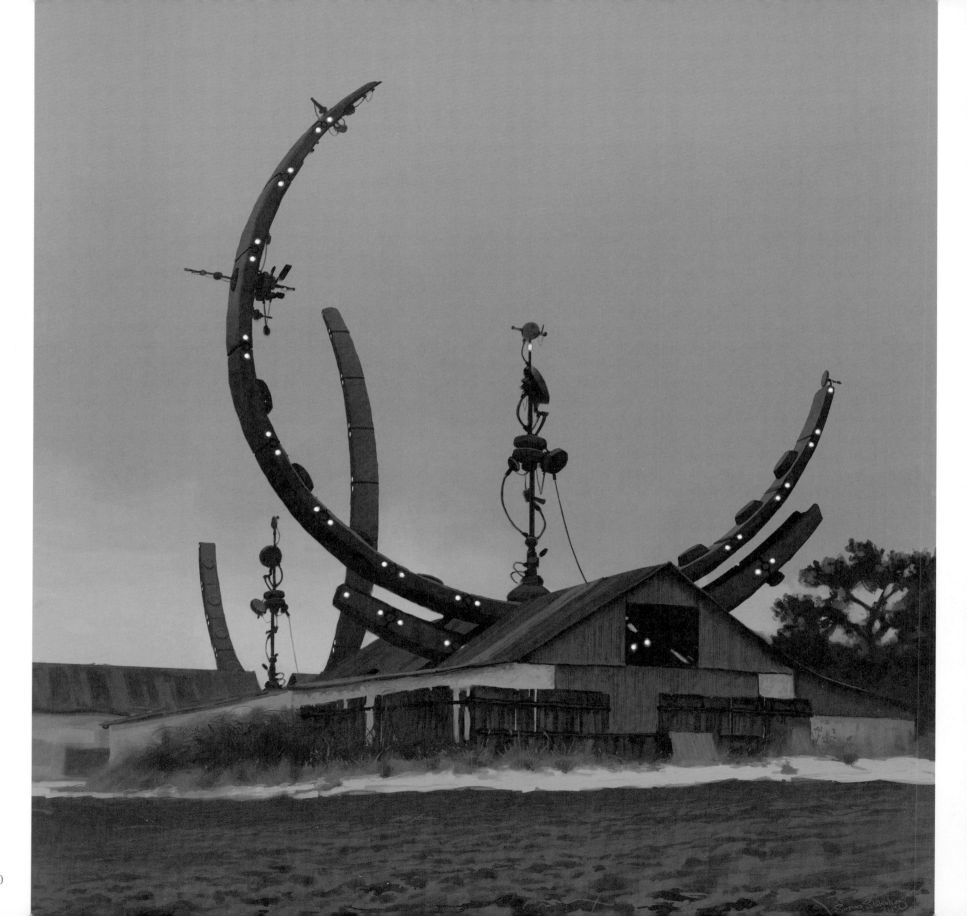

THE SPONTANEOUS COMBUSTION OF CONNIE FRISKE

If you stood down by the bus stop at Löftet during quiet nights you could hear a low buzz coming from Göran Friske's focal towers. Every other minute the towers were calibrated to the moon's position in the sky, and the soft whine from their servo engines drifted across the fields. Nowadays it's quiet at Löftet's bus stop and the impressive arches are gone. Only the barns remain.

Up until his daughter's death, Göran Friske cultivated a plant that he called lunar root. The towers focused the light of the moon and a flower box was placed in the focal point. A root vegetable grew in the box. This vegetable was said to have amazing properties: besides easing rheumatism, migraines, back pains, headaches, and all sorts of ailments, it could also cure cancer and other deadly diseases, according to Friske. In the picture, the towers are shown at the assembly stage. The small cylinders on the inside of the arch are the flower boxes. The main arch was lowered through the roof of the barn for harvesting and planting. Then the tower was raised so that its axis reached above the roof. This gave the tower enough mobility to track the movement of the moon across the sky, during all seasons.

Friske's daughter's body was so badly burnt that cause of death was hard to determine, though there was serious speculation that it had been something as odd as spontaneous combustion. Constance Pernilla Friske had extremely high levels of acetone, a highly flammable substance in high concentrations, in her body. The medical examiner's assessment was that the acetone in her body was a side effect of a so-called ketotic state, probably caused by a one-recipe diet.

If Göran's career as a local entrepreneur and neighbor had been a mess already, it was completely derailed when it was revealed that Connie had, since an early age, been living on a strict diet consisting almost exclusively of lunar root.

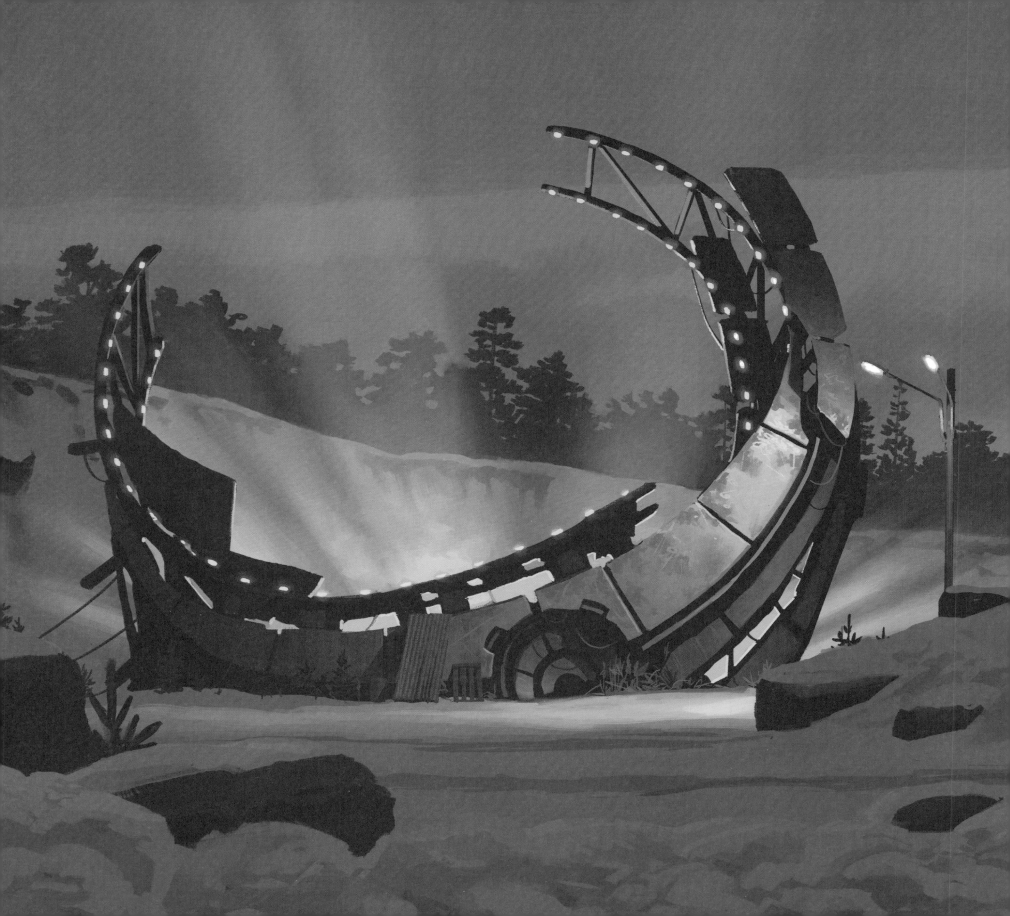

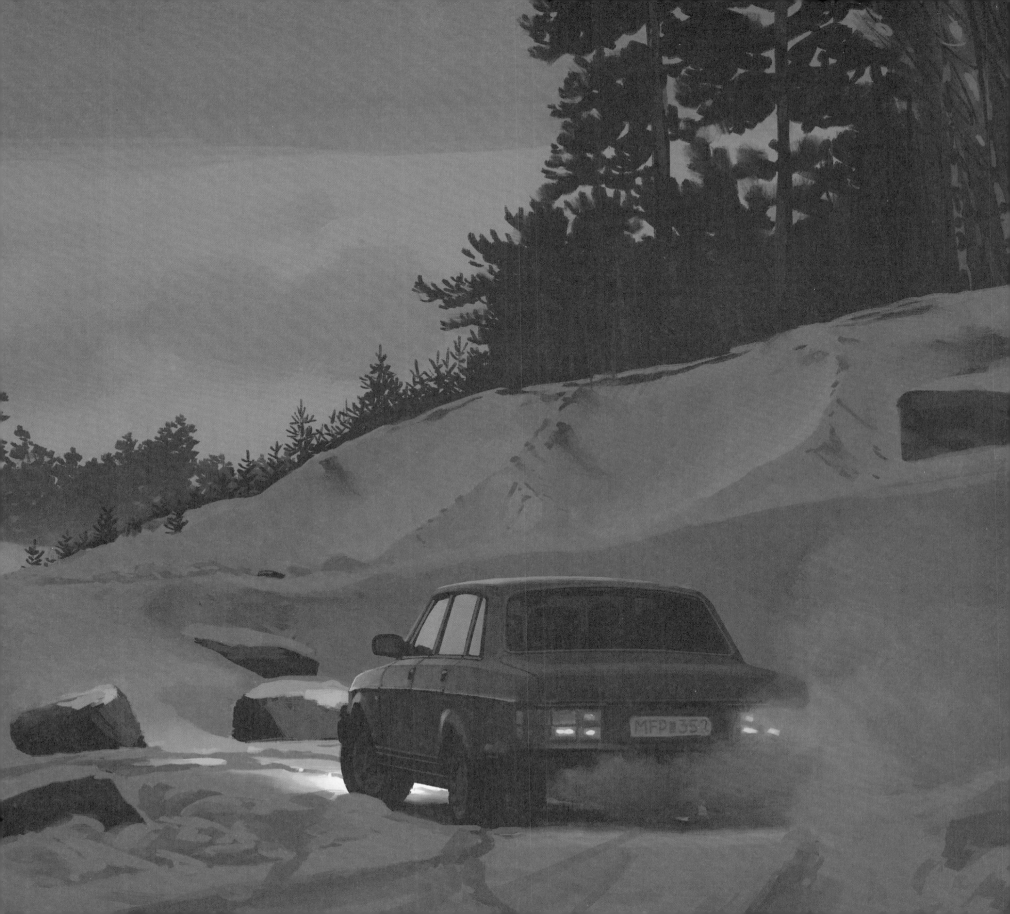

THE HOUSE OF THE SAVAGES

At the end of a forgotten dirt track in Karlskär was a completely run-down house. The blinds were always down, and something dark ran in rivulets down the Eternit facade. A moist mass of cardboard boxes, pillows, and mattresses had erupted from the front door, like the house was vomiting forth its stomach contents.

This was the rumor: a small boy lived in the house with his obese mother. The boy didn't go to school and could neither read nor write. It was doubtful he could even speak. The father was in prison and that was probably just as well, because he was an infamous dirty old man. The mother was firmly rooted to the couch in front of the TV. She was so fat she couldn't move, and she couldn't be bothered to take care of the boy anymore. The poor thing had to fend for himself, and at dawn he prowled around, digging through the neighborhood's garbage cans like a rat, looking for scraps of food. Now and then you could hear ecstatic whoops when he managed to bring down a boar or a deer. Supposedly he had speared visitors from social services on a few occasions, and had maybe looted a pizza delivery truck or two.

Anyway, the reason we sneaked around that godforsaken property was that we had heard he hid something amazing in the hen house. It was said he had a live dinosaur in there—a raptor he had raised since he found it in the fields behind the school, when it was still a nestling. Now it was grown and someone had seen it sneak around down by Sätuna, with the boy on its back!

One day, the lower parts of a body were discovered not far from that house, still dressed in a pair of jeans. It was found in a bank of snow, splattered with red. Nobody knew where the upper parts of the body were, but the assumption was that they were hidden in various fox dens across the area. How the victim had been killed was also unknown. Maybe it was a hit-and-run or a suicide. What was clear was that the body belonged to the boy's father, evident from the wallet containing his ID, which was found in the back pocket of his jeans.

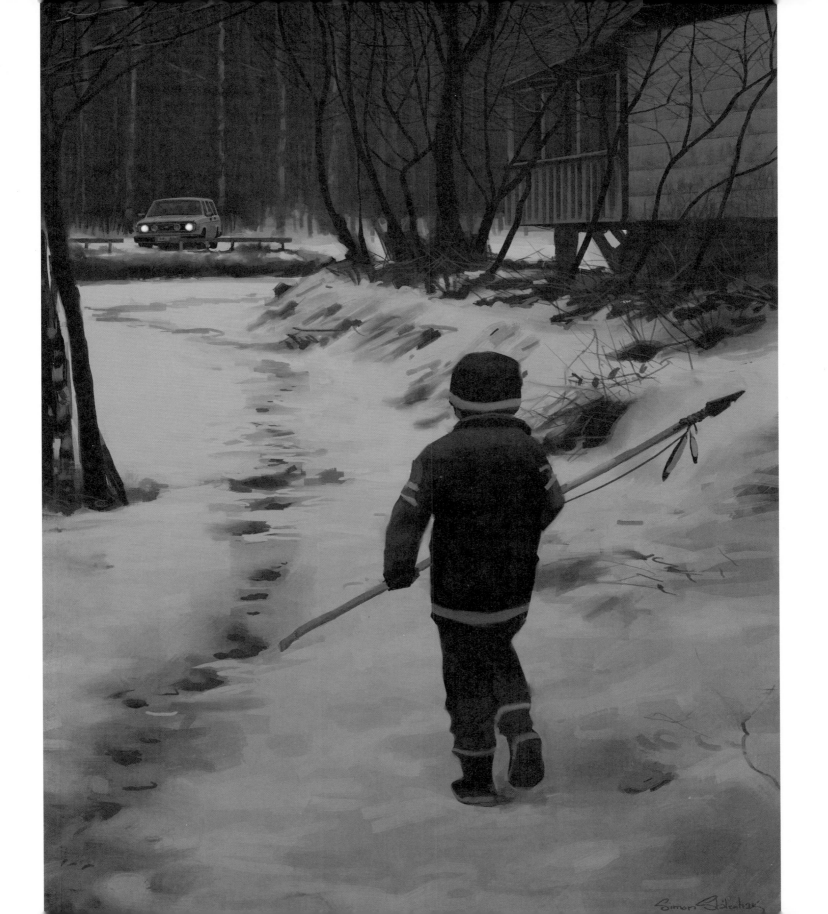

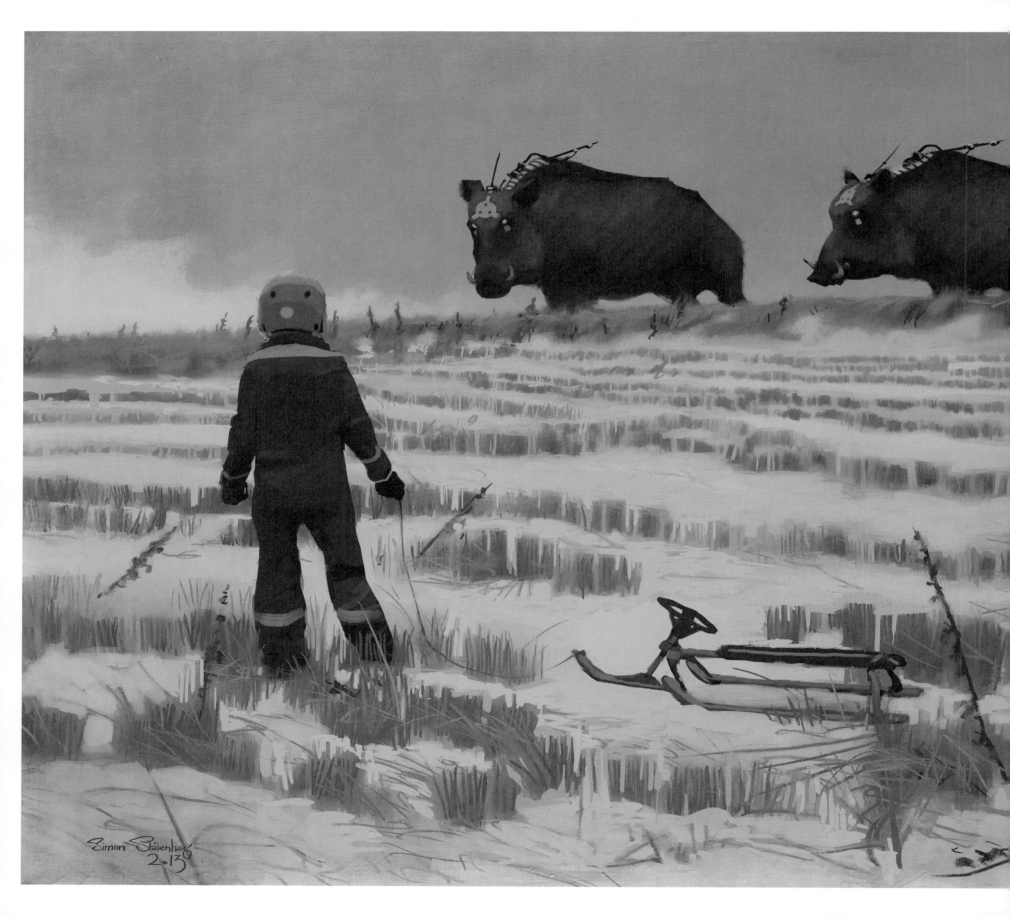

THE CYBERNETIC BISON BOAR

In the winter of 1990 there was a rumor that some animals had escaped from the laboratories at the FOA facility on Munsö. Some dark, big animals had been sighted in the woods around Sätuna on Färingsö, across from Munsö. They had probably crossed on the ice during the night. Everyone was excited and speculated wildly about escaped abominations. One day Little Tomas in 2B claimed he had seen the animals. He had encountered them in the stubble fields on the way to Kvarnbacken. We all stood in a circle around Tomas during our lunch break, asking questions: they had looked like boars, but were the size of bulls; they had glowing green eyes, and weird antenna things on their heads. Little Tomas had not been afraid, because he was good with animals. He had pitied them a little, because they had to walk around with those antennas on their heads.

There were no more sightings of the escaped animals, but all through that winter we found, much to our excitement, plenty of tracks we couldn't explain, right up until the flowers bloomed in the meadows.

HOTEL ÅKERFELDT

Göholmen is a small island off the northern part of Svartsjölandet. Närke-Väst Energi AB had built an experimental power plant for wireless transmission of electricity on this small, forgotten piece of land in the '60s, with grants from the government. They tried to create a stable and economically viable transmission of electricity from the Bona reactor to the station on Göholmen. The results were meager by the end of the '80s, but the operational costs of the experiments were relatively low so the grant was continued. The caretaker and only permanent resident of the island was Axel Åkerfeldt, a malformed, ancient scarecrow of a man who lived in a 28-square-meter shed next to the station.

We used to make our way out there, across the ice, in the winters. On the island, you had to fight your way through deep snow and across the properties of summer houses. When you arrived at the station your toes ached from the cold and your wrists were chafed from the edges of your gloves, but Axel's hot chocolate and biscuits were worth every hardship. "Hotel Åkerfeldt," as Axel called it, was open until November 1994, when an exploding vacuum tube ended the caretaker's life. Shortly thereafter the station was torn down.

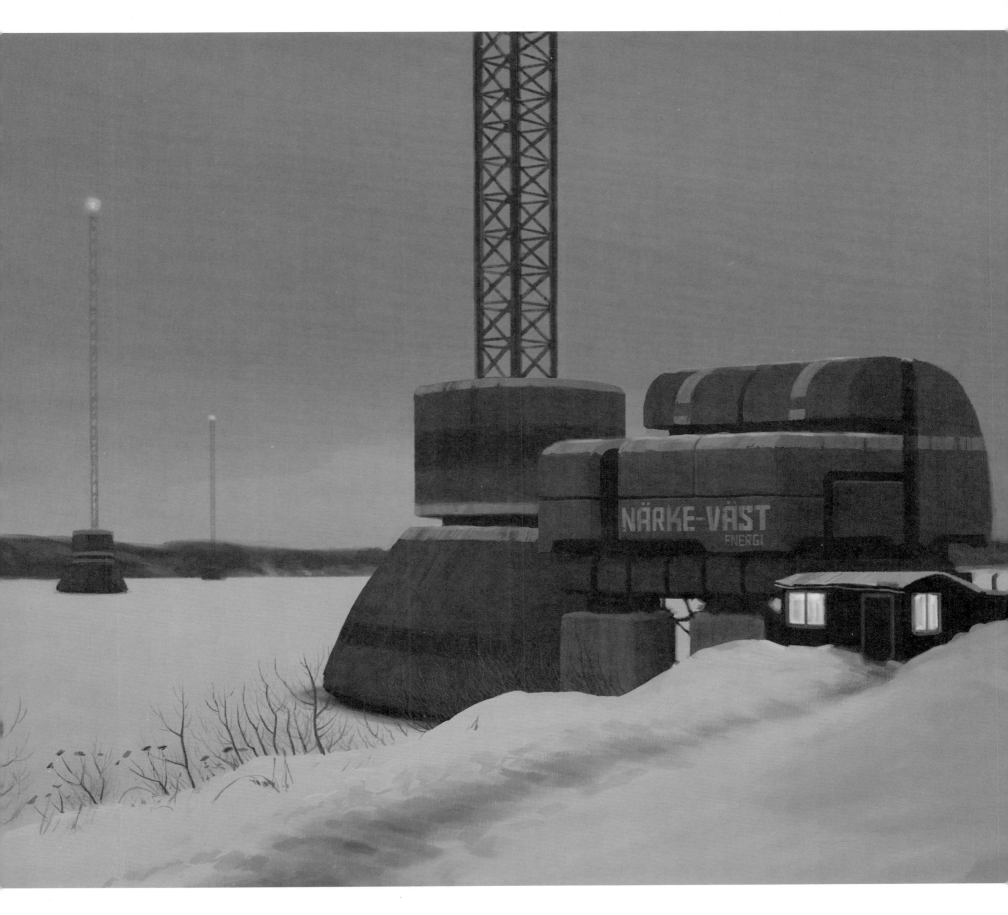

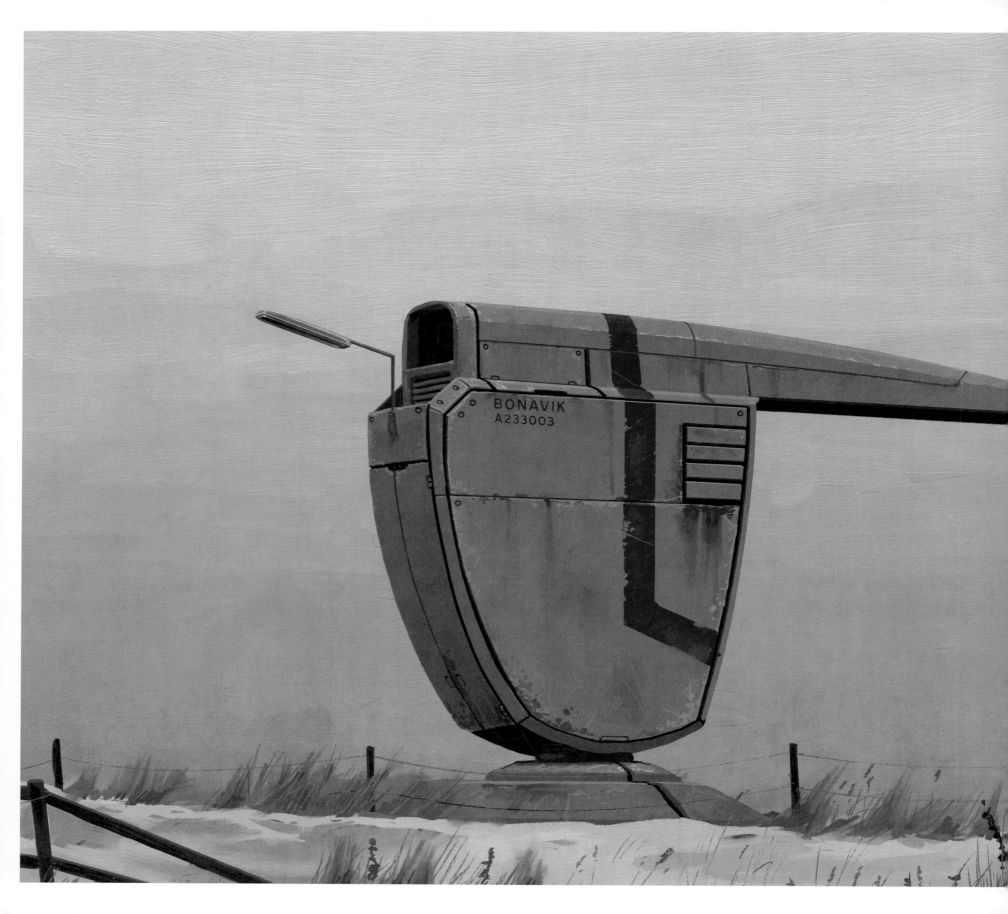

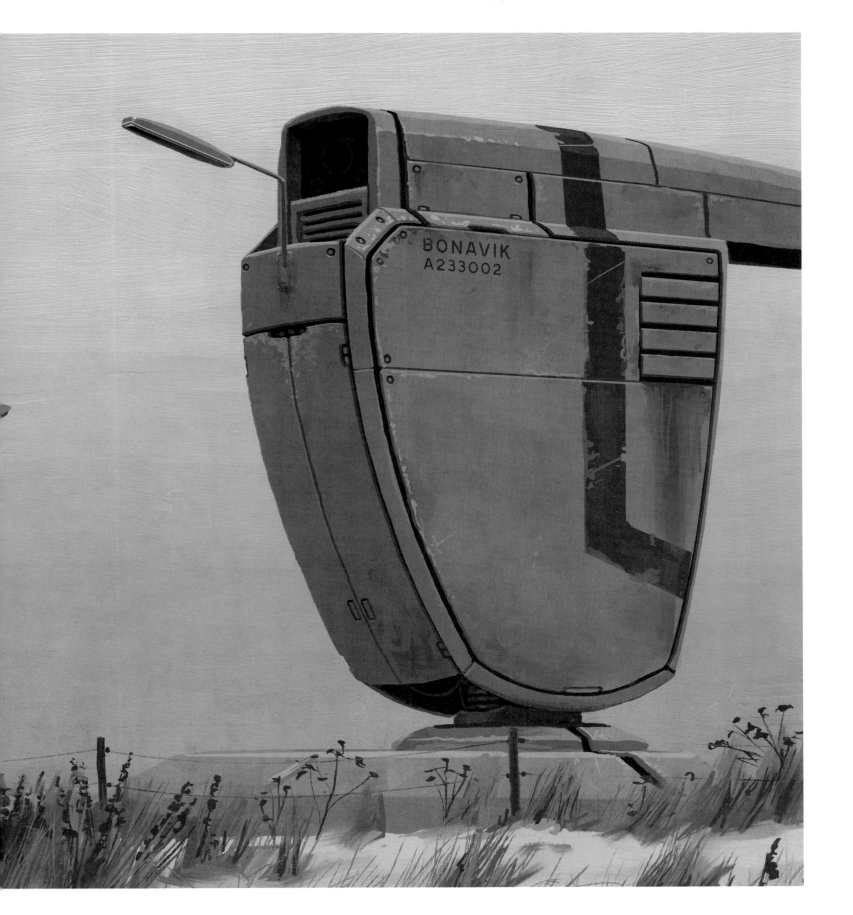

THE DISAPPEARANCE OF GÖRAN FRISKE

The Friske Wheel always looked funny, squeezed in between a Volvo and a Saab on the road into town. Göran started acting oddly after the tragedy with his daughter Connie. I remember the uncomfortable mood when he entered the stage at Folkets Park one late summer night in 1993, the year after Connie's death. He was dead-drunk and bellowed old prog rock songs. When people tried to get him off the stage, he screamed, "I killed my own daughter! And Ragnar!"

That's actually my first memory of someone being drunk.

A few months later he simply disappeared. Soon the Friske Wheel was found, crashed in a ditch down by Ilända. The door was open and an empty whiskey bottle was found in the cockpit. Betty Friske never heard from her husband again. Everybody assumed he had left the country or gone and drowned himself in Västerholmsviken. Betty soon married Lennart Ek, whom she had been having an affair with for a long time anyway.

A few years later I experienced something very strange. I dated Cindy Friske, Göran's youngest daughter, for a while in high school. One day she showed me something very macabre. Under the bed, she kept a package that had been delivered to her a year after her father's disappearance. She removed a large glass jar from the box:

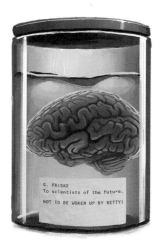

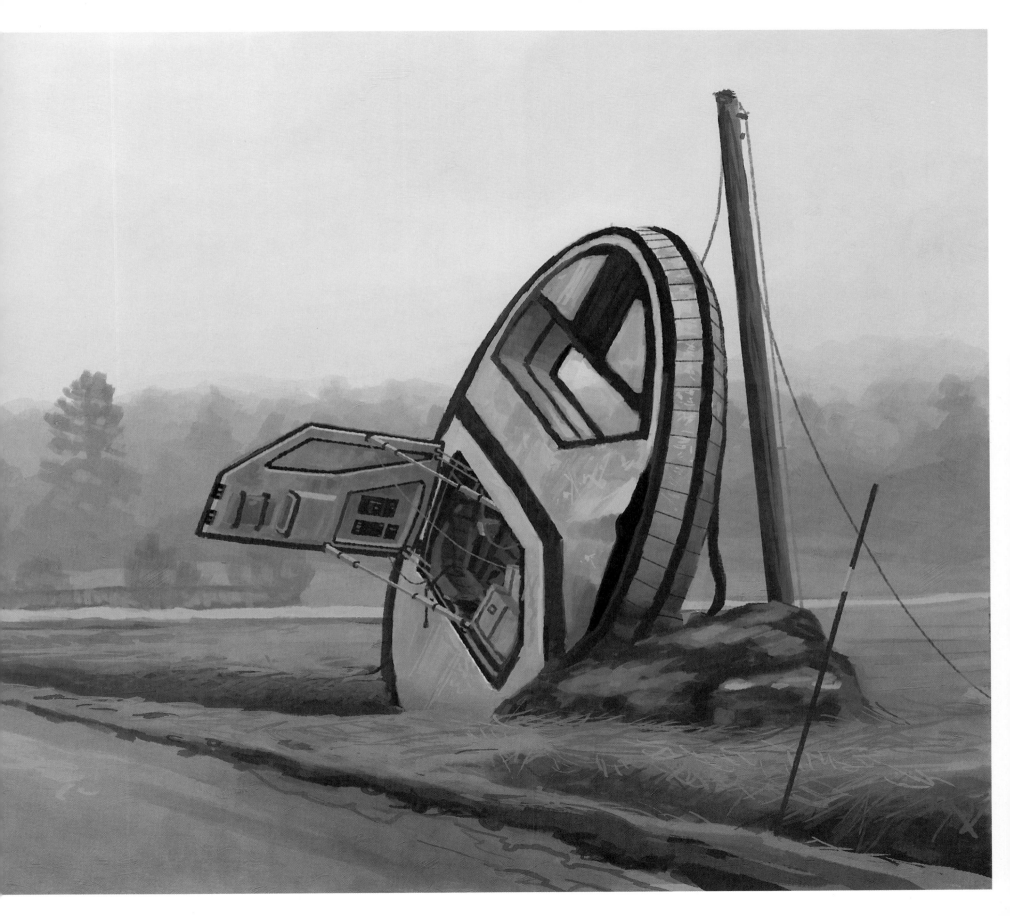

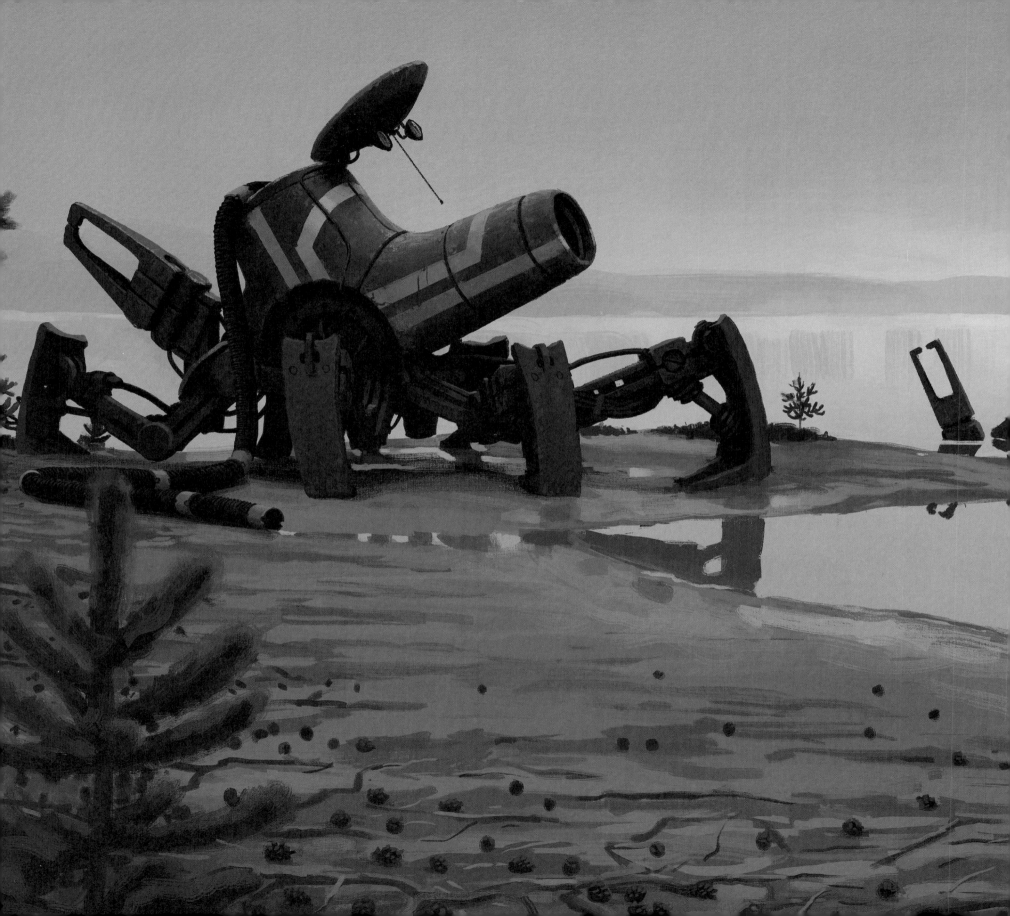

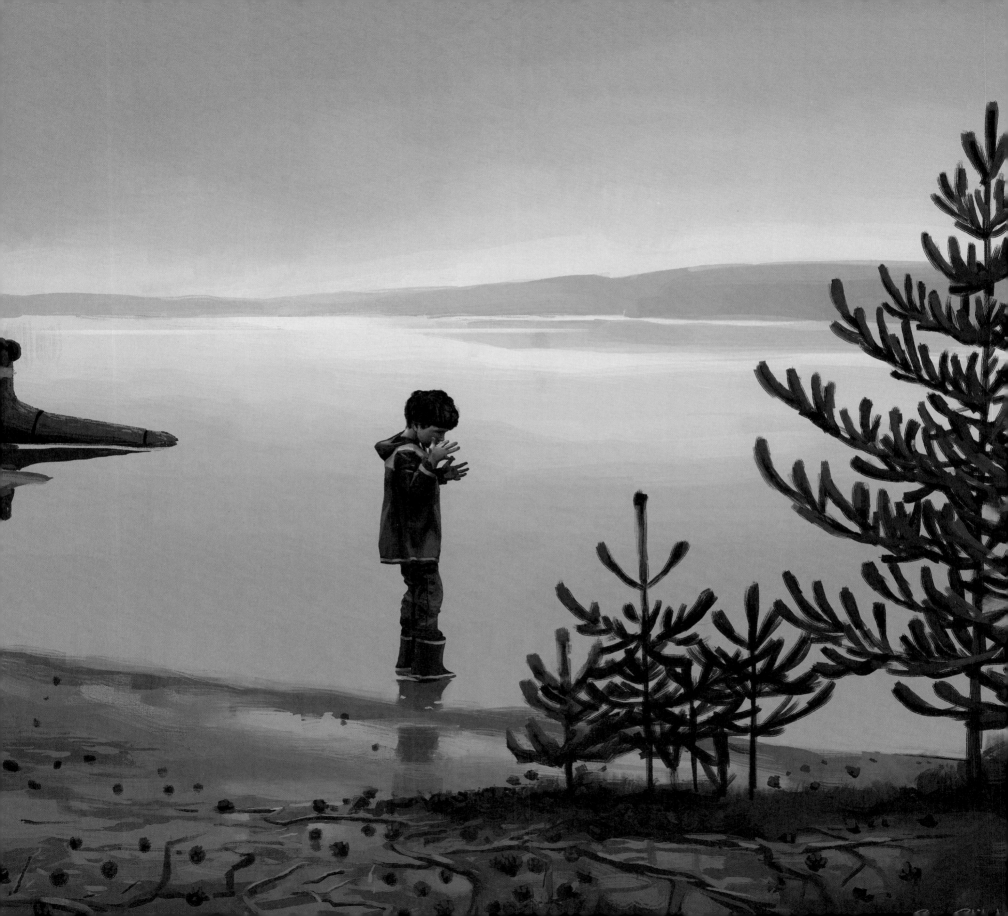

PONTUS'S KATA

There was a hole in the fence behind the factories in Lunda that led to a place where reeds grew straight out of the asphalt and the air smelled of nettles. We used to sneak in there and look for old stuff, like furniture, a vacuum cleaner, or maybe even a computer. We would regularly find things of a more exotic nature; magnetrine discs, echo spheres, and hydraulic arms. The highlight was the pit filled with discarded androids. There seemed to be a remnant of electricity running through their circuits, because they focused their eyes on whatever you held up in front of their faces.

Once we took Pontus there and he went wild when we showed him the androids. With great effort, he managed to drag one of them out of the pit and propped it up against a wall. Then he began some sort of karate display. He landed a few kicks but it looked like he mostly hurt himself so instead he embraced the android, started thrusting his hips at it, and shouted:

"Onegaishimasu, baby!"

I don't know if those kicks had hit a switch or something because mid-thrust the android suddenly locked its arms and legs around Pontus, and he howled in pain. Olof and I had to pull and kick at the thing for several minutes before it relented. All ended well; Pontus gave us his *Golden Axe* in exchange for us not talking about the thrusting incident at school.

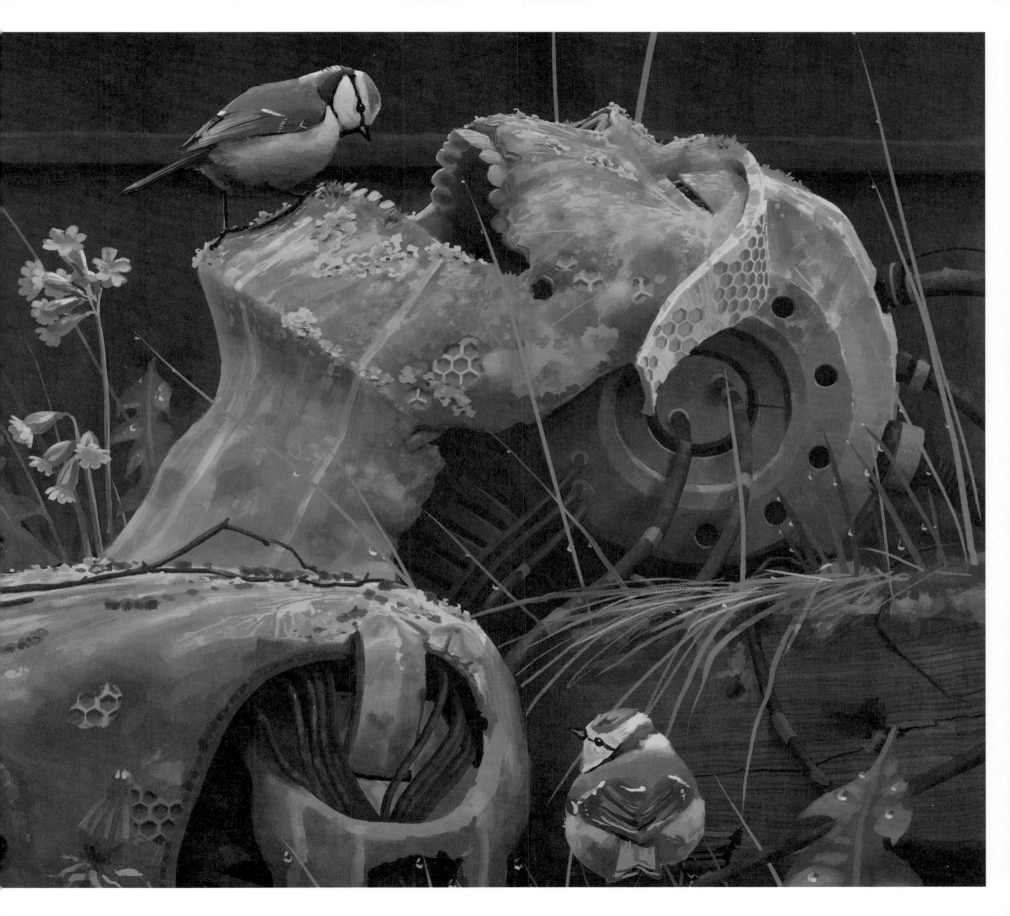

THE METAL DETECTOR

The Gödel pulses. (That's Gödel with a G as in Gladys, not George.) That's what the disturbances that occurred as a side effect of the experiments in the Loop were called. Usually you only noticed the kitchen lamp or TV screen flickering for a brief moment, but occasionally the effects were more tangible. Fuses blew, cars refused to start, and light bulbs shattered. Sometimes you felt the ground vibrate and your ears pop. I remember a frightening episode when I was around six, when suddenly the voices of everyone around me sounded really deep. Probably just a Gödel pulse according to my father, who was walking around pulling at his nose. I suppose he was trying to equalize the pressure.

Every family in the area had been issued a small blue pamphlet from Riks-energi that contained information about how the neighbors of the Loop might be affected. The Gödel pulses had a separate chapter where the side effects were listed and described very pedagogically. The last page contained safety instructions that could be removed from the pamphlet. At our house, that was up on the refrigerator door.

One weekend we had a metal detector in the house. My father had borrowed it from work. I remember it well; I ran around with that device, all euphoric, trying to detect coins, nails, and old toys that were scattered throughout the garden. It started screeching horribly when my father was about to try it out, and I was terrified of having damaged it somehow. My father looked annoyed and tried to make the device stop howling, but soon he stopped. "Listen," he said. The screeching rose and fell slowly. It sounded eerie. I remember that moment so clearly. My father stood perfectly still and listened intently to the noise, me right next to him—equally focused, if not more—eagerly trying to discern my father's mood and where it was all going.

Then the noise stopped. My father glanced at his wristwatch and said,

"Gödel pulse!"

My father claimed he had needed the metal detector to find a lost set of keys, but a few days earlier I had accidentally witnessed him as he angrily tore his wedding ring off his finger and threw it out in the rye field behind the house.

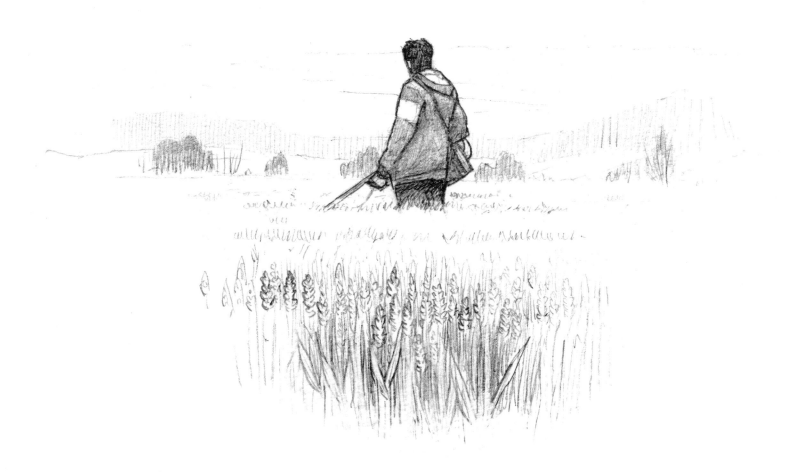

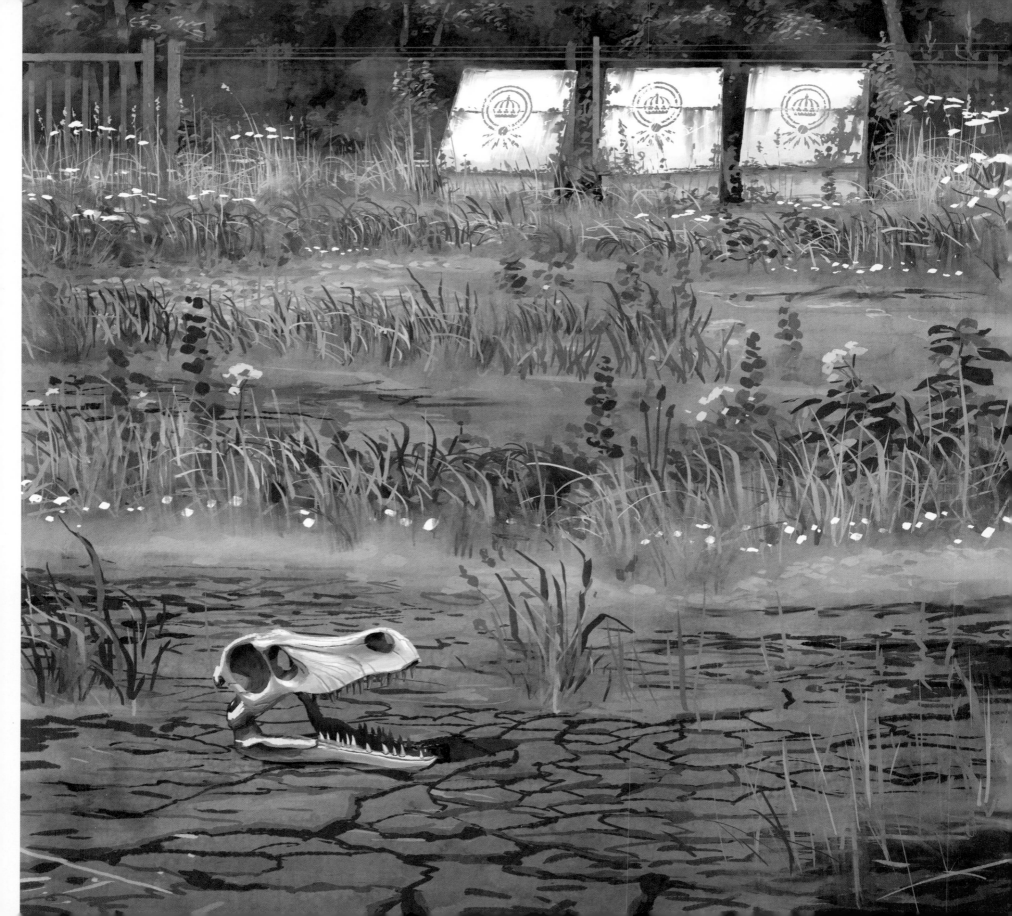

REGARDING THE EXTINCTION OF DINOSAURS

After an awkward weekend up in the mountains with my father, I returned to Svartsjölandet knowing that I would soon have the honor of being a child of divorce. If I look at my memories from the side, that weekend is a black line, like the dark boundary in the rock layers left by the disaster that killed all the dinosaurs.

I was drawn to other children of divorce after that weekend. We went for long walks, staring at the ground in front of our feet. A new and dark inner landscape had opened up, and we wanted nothing more than to talk about it. We abdicated from childhood, tried to learn how to talk as adults, and shamefully glanced back at our playgrounds.

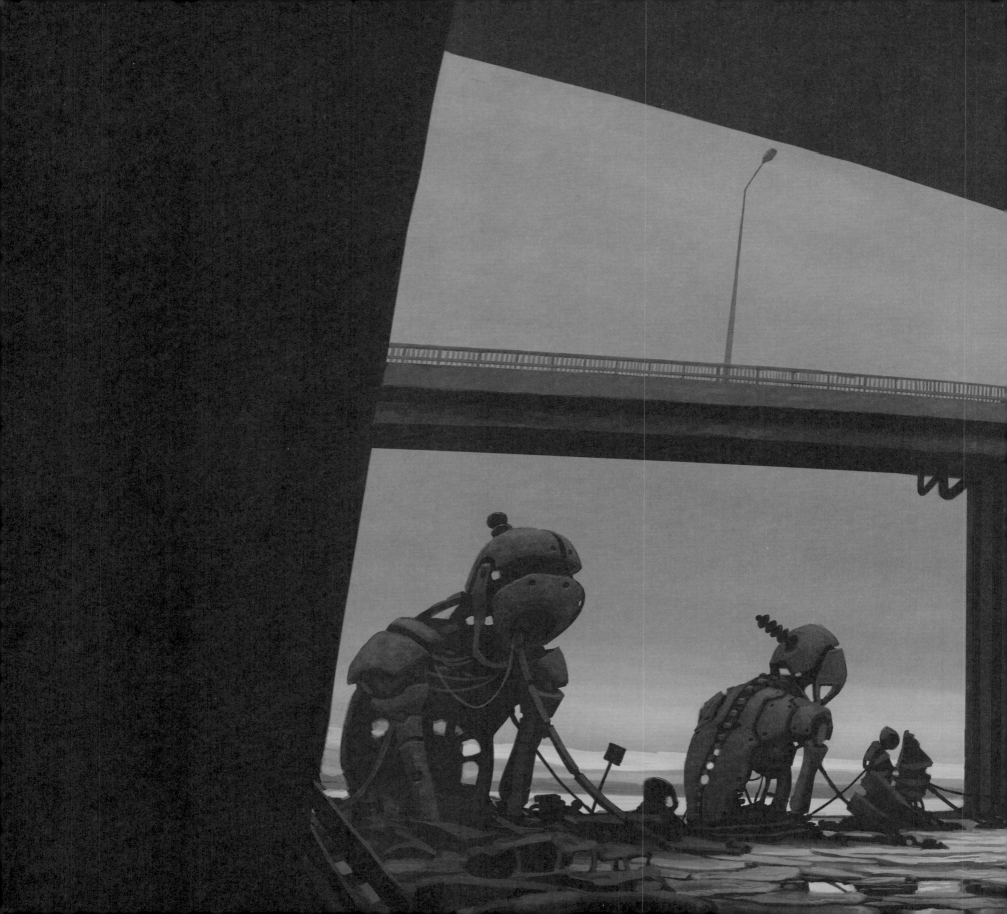

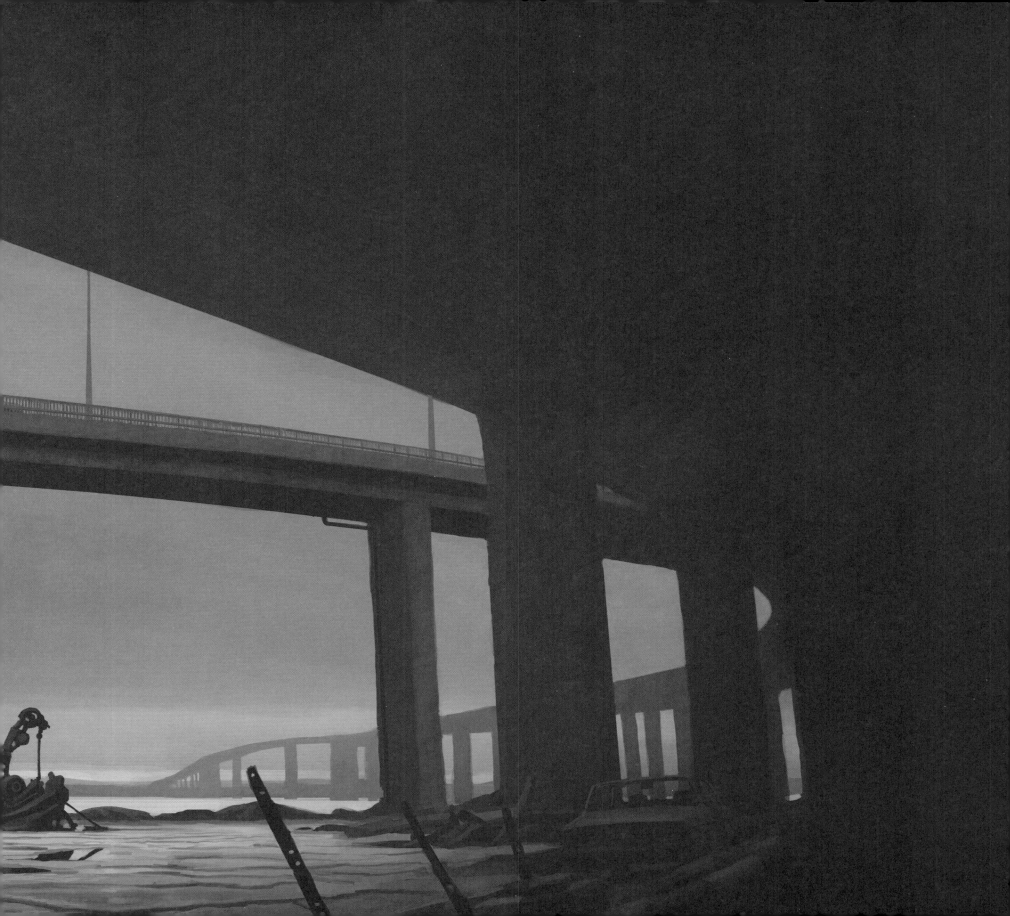

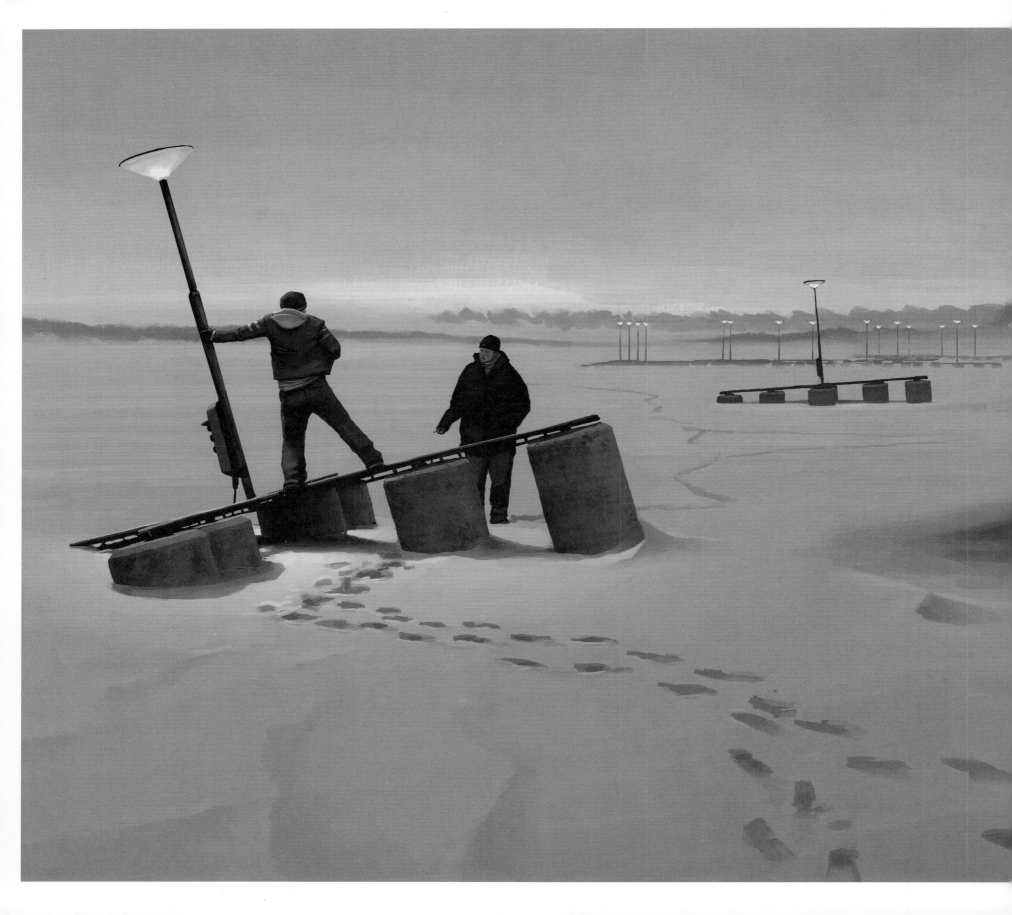

FINAL WORDS

The Loop was finally decommissioned on November 5, 1994. By then we all had acne. Society was changing; it was obvious to everyone. The yellow cars from the Loop disappeared from the roads. Government-owned companies became privately owned and changed names. We did not grieve these changes when they occurred; we were fully occupied with our greasy skin and breaking voices.

Playtime was replaced, piece by piece, with computers. Soon we spent almost all our free time in the glow of a monitor. But at least once a day each of us was thrown outside by an agitated mother (nearly all our fathers were remarried and had moved away by this time), and then we returned to our old playgrounds like zombies around a mall. We sat wedged into the swings outside the school, or crouched in someone's old treehouse, smoking stolen cigarettes.

We walked in long lines through winter nights, and you could see little points of light go on and off in the darkness—cigarettes smoked by teenagers who had gathered around their wrecked memories, like a requiem.

We made our nights our days, squinted at the horizon, and sighed. Way over there, the morning dawned.

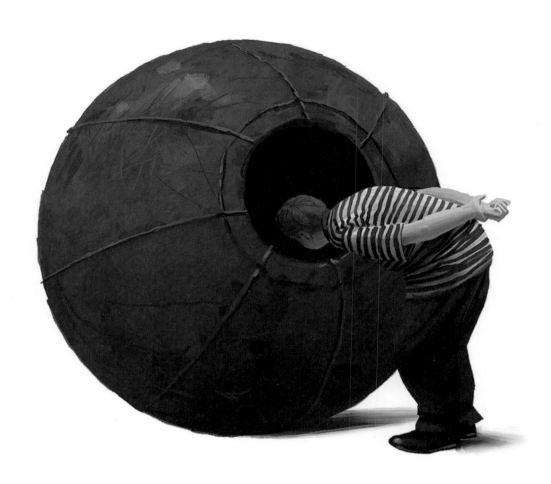

In this English edition, I would like to take the opportunity to express my gratitude for the enormous show of support from people all over the world. Over the past few years, I have received enough warmth and well-wishes to last a lifetime.

A whole new chapter has begun with the fantastic support that Free League Publishing and I received for this Kickstarter campaign. This would not have been possible without all of you contributors to the project, and I would never have believed your response would be so overwhelmingly positive. There are no words that adequately describe my gratitude—because apart from the purely financial support, you give me enormous inspiration and energy to continue exploring the strange world of the Loop and to capture all those fleeting memories from a time that never was.

Apart from Free League Publishing and their fantastic efforts in bringing this book to life, I would like to take this opportunity to thank the following people: Josefin and Ola, my mother and father and my wonderful siblings, all my childhood friends from Mälaröarna (who helped create all those memories), everyone on Twitter, Tumblr and Facebook who has supported me and shared my images (I won't forget you @maettig for the idea about the Fire watchers), and all the creators of the photographs, poems, movies, books, paintings, sculptures, models, music pieces, tutorials, video games, role-playing games, Lego builds, buildings, songs and video clips, etc. that have inspired me and been invaluable during my process.

ALSO BY SIMON STÅLENHAG

Things from the Flood
The Electric State

Skybound Books / Gallery Books
1230 Avenue of the Americas
New York, NY 10020

Copyright © 2015 Simon Stålenhag and Free League Publishing

Originally published in Sweden in 2016 by Fria Ligan AB

First Skybound Books/Gallery Books hardcover edition April 2020

SKYBOUND BOOKS/GALLERY BOOKS and colophon
are trademarks of Simon & Schuster, Inc.

For information about special discounts for bulk purchases, please contact Simon & Schuster Special Sales at 1-866-506-1949 or business@simonandschuster.com.

The Simon & Schuster Speakers Bureau can bring authors to your live event. For more information or to book an event, contact the Simon & Schuster Speakers Bureau at 1-866-248-3049 or visit our website at www.simonspeakers.com.

Kickstarter Edition Credits

Illustration & Text—Simon Stålenhag Color Adjustment & Prepress—Dan Algstrand
Editor—Nils Karlén Translation—Martin Dunelind
Graphic Design—Christian Granath Proofreading—Rebecca Judd, T.R. Knight
Project Manager—Tomas Härenstram Initiator—Magnus Lekberg

Manufactured in China

1 3 5 7 9 10 8 6 4 2

Library of Congress Cataloging-in-Publication Data is available.

ISBN 978-1-9821-5069-3
ISBN 978-1-9821-5070-9 (ebook)